A Mod Portrait of The City

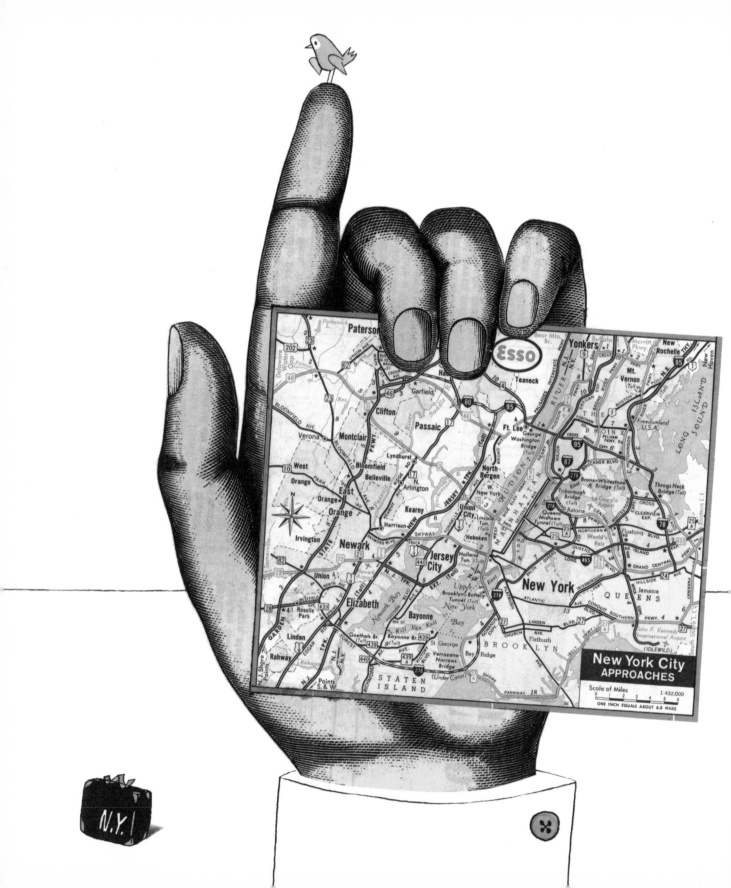

NEW YORK
A Mod Portrait of The City

Vladimír Fuka • **Zdeněk Mahler**

UNIVERSE

As the world has gotten smaller, and we've learned more about history, what we once thought to be fact has changed and even more mysteries are created. We used to think Columbus discovered America, and then we believed the Vikings got there first—after Japanese fishermen—although long before that Native Americans came down from the north. Who knows what we'll think next? Maybe the only thing to do now is to cover it back up and discover it all for the first time . . . again.

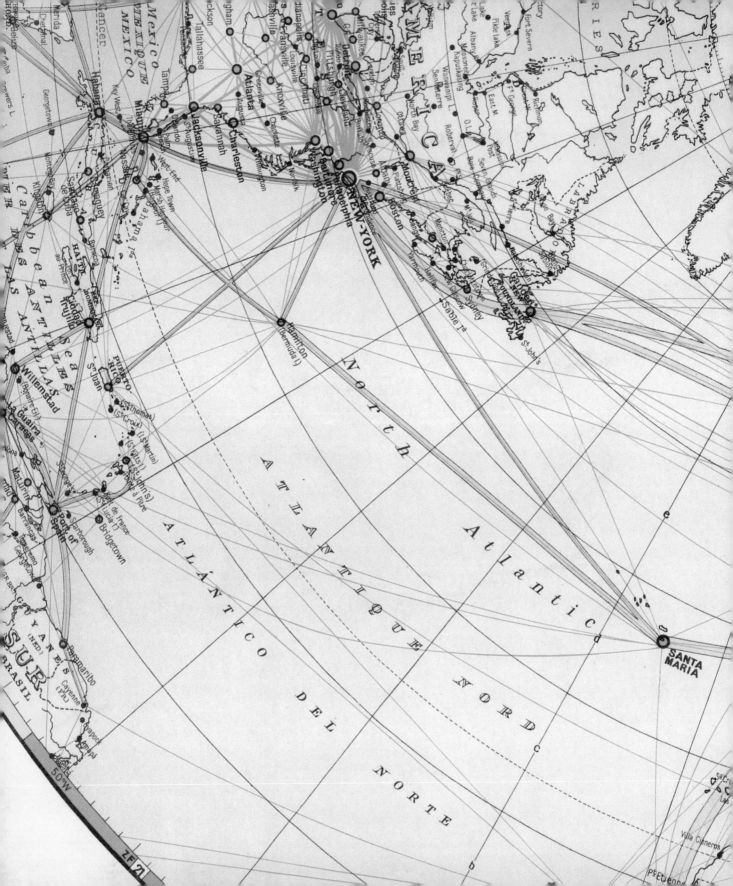

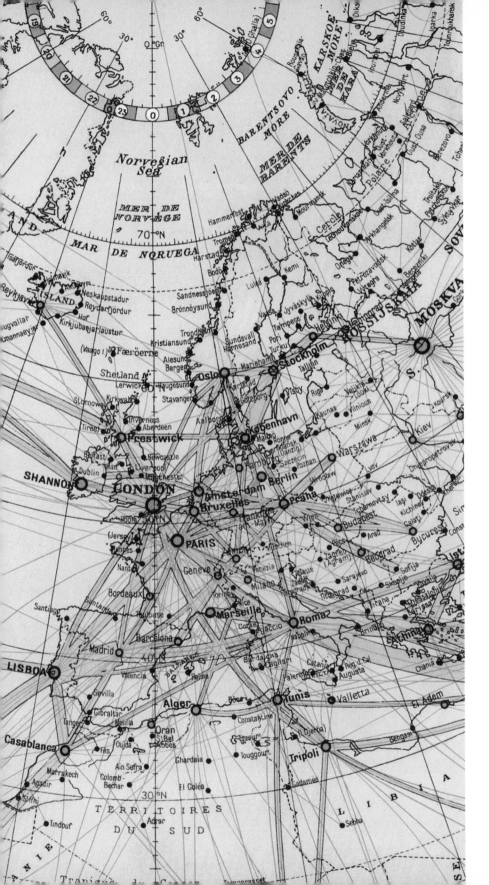

Getting to
New York is easy.
Getting to the plane?

THAT'S HARD.

As soon as the plane pokes its nose through the clouds and into the sun, time takes a rest. You should rest, too, because if you're flying west to get to New York, your longest day awaits.

When it's noon in Prague, New York is just getting up.

Europe is six hours older than North America.

Over the course of a hundred years, a voyage that once took a month now takes just hours.

In a supersonic jet, you'll land before you take off. Your watch—if it's working right—will go back. (It'll stop if it's not.) You've made a journey forwards and backwards at the same time. The trip will make you younger.

Below the plane, on the water,
the shadow draws
a dotted line along a
a legendary route,
along which millions have journeyed.

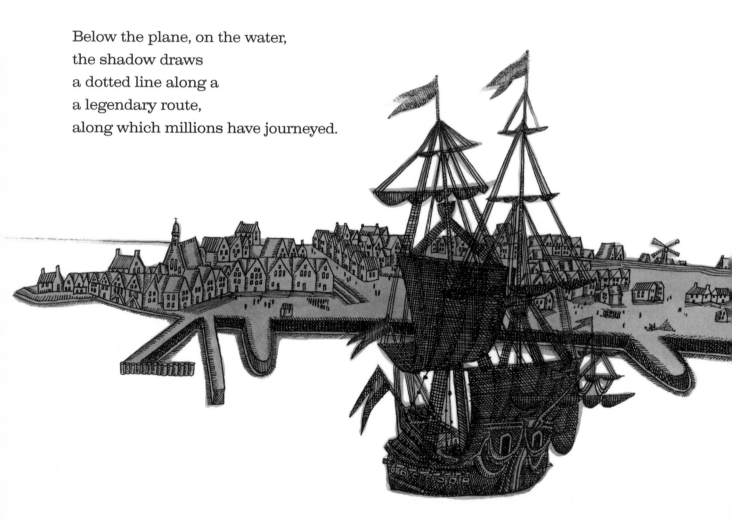

Whether because of hunger, running from injustice, or looking for a new opportunity, everyone who immigrates to America has shared the same dream of a better life for his or her family. Immigrants' eyes once stared into the fog, searching for the city with it all, their voices anxious to call: Land!

And even now, although you know
you won't be able to
see her from so high in the sky,
you search the horizon for
the Statue of Liberty, which
shines in welcome in the bay . . .

The world is within reach.

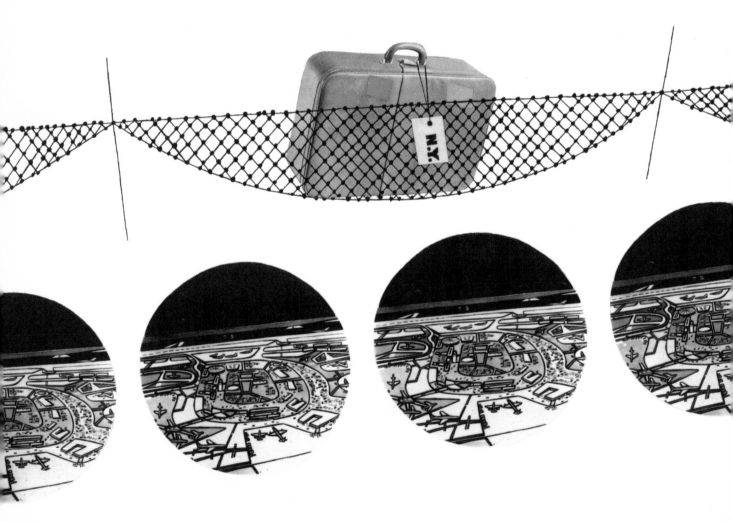

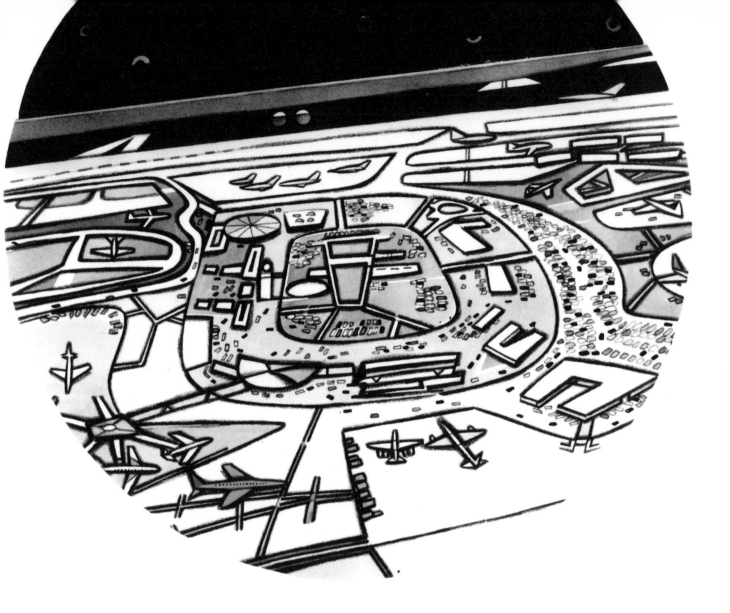

Bump up and down and **you're in New York.**

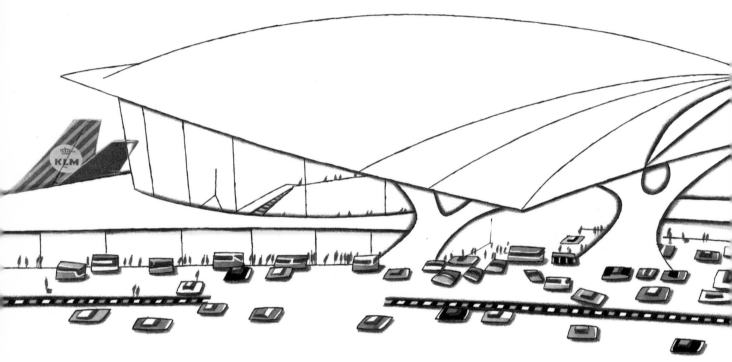

ALL ROADS LEAD TO **NEW YORK**.

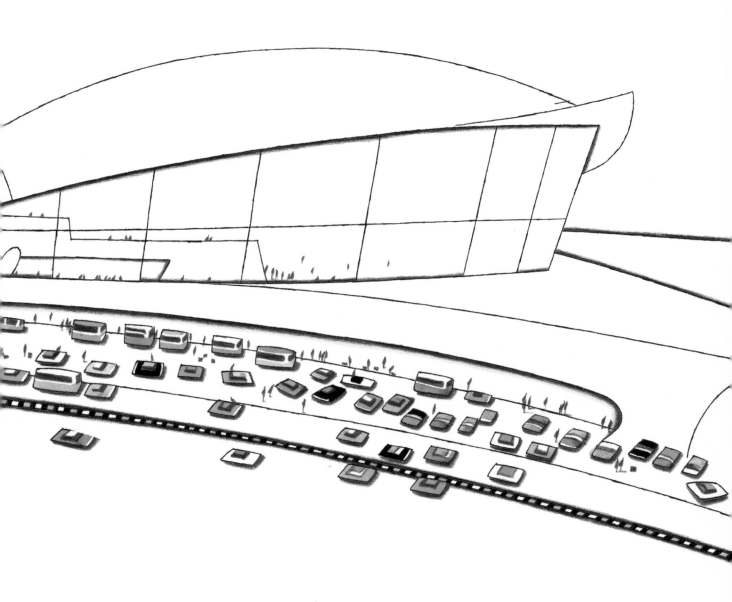

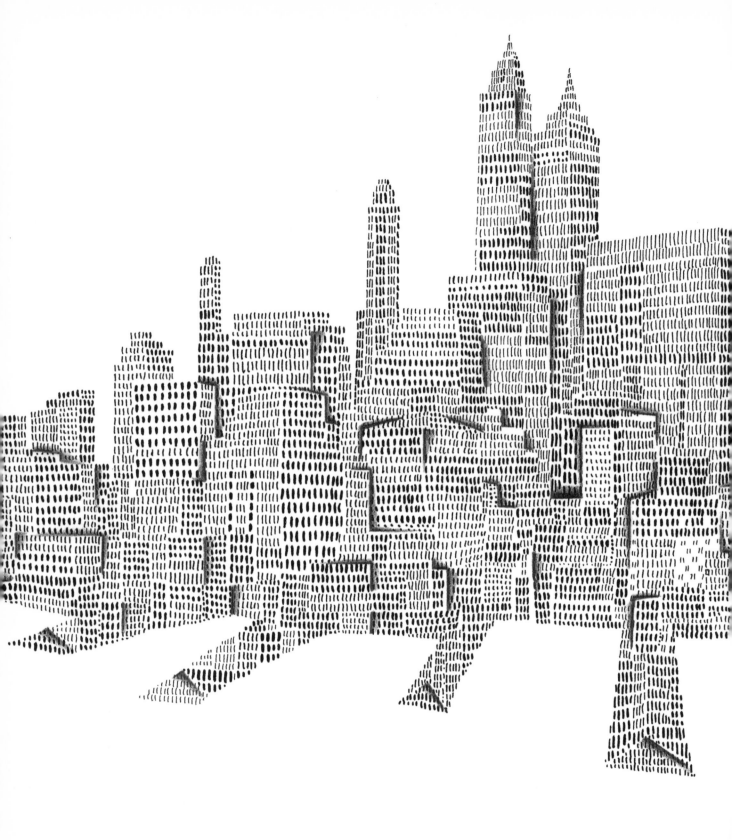

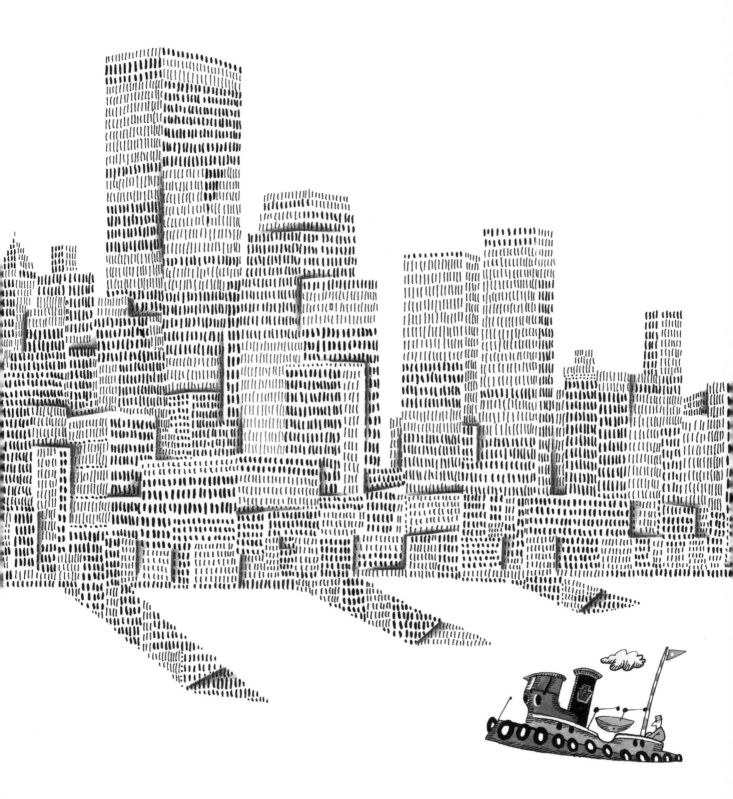

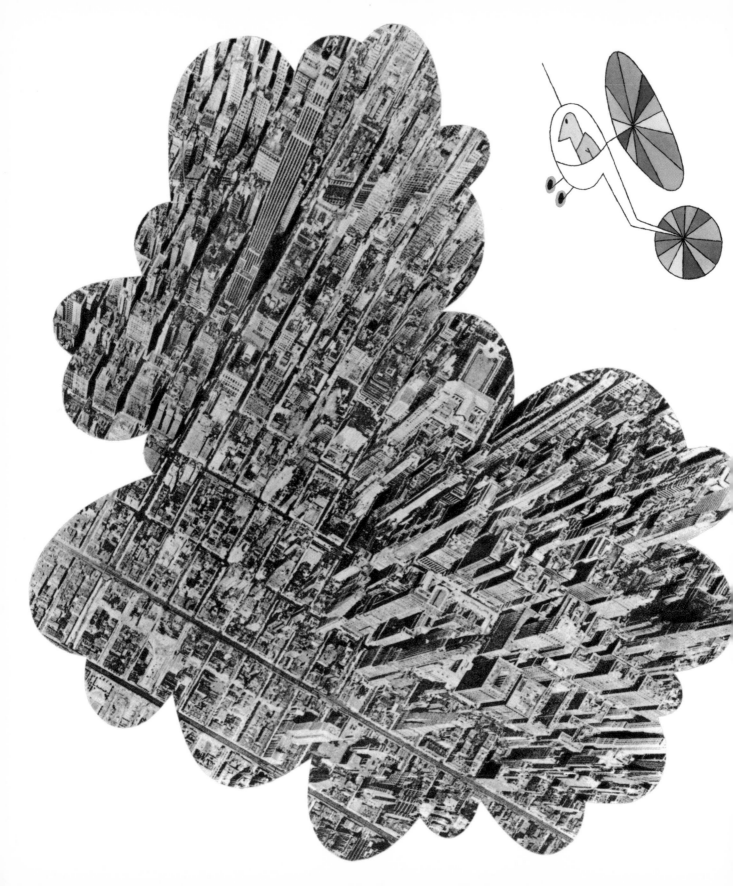

A helicopter can take you over Manhattan, the center of the city.

It is like the spiny back of a gigantic lizard
emerging from the deep before turning to stone,
stretching out with a silent crack—

It is like a planetary launching pad packed with
rockets—all systems go!—

It is like a poem, crisscrossed electric verse—

It is the Milky Way on Earth—

well—it is!

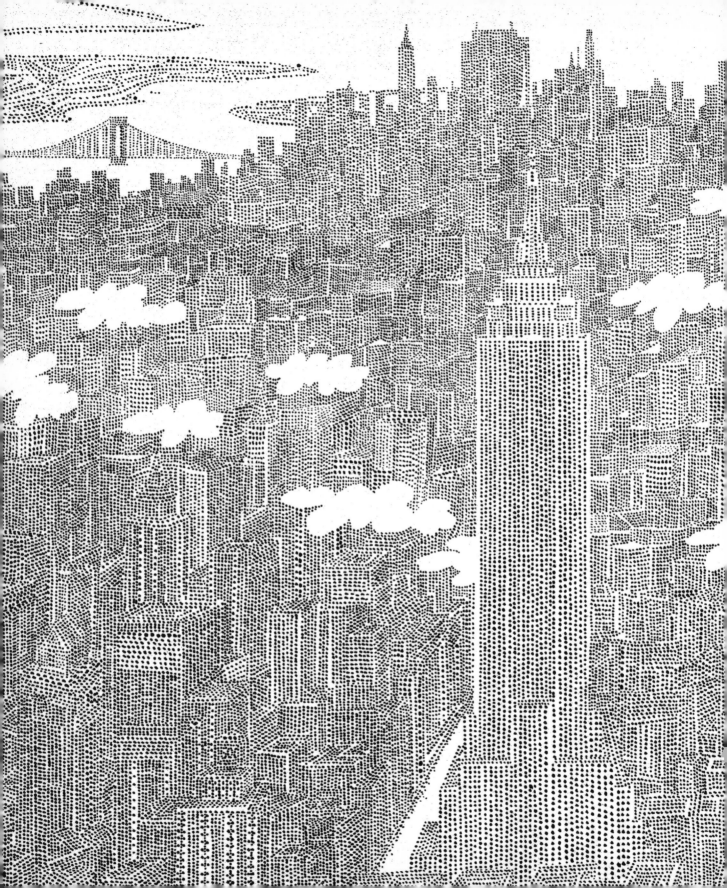

To look around, climb the highest tree in Midtown—

THAT IS, take the express elevator to the 102nd floor of the Empire State Building. A light rain falls from the clouds around you down to the city beneath your feet. While you're there, take a look through the binoculars on the observation deck. But just between us? One of them is magical. If you look through it backwards, you may be able to see back in time . . .

In the beginning, the sun shines gently upon green forests. The rivers teem with fish, and the mountains echo with the sounds of nature.

In **1524**, Native Americans watch as an Italian named Verrazzano drops anchor in the bay. His brother sketches the shore, the shallows, and the straits—but they sail away and, once again, time slips quietly by—until **1609**, when an Englishman, Henry Hudson, shows up—he sails for the Dutch, trying to find a passage to India—then in **1613**, a group of castaways settle here involuntarily—their schooner caught fire—and in **1620**, the *Mayflower* wanders to Cape Cod with its boatload of pilgrims—in **1626**, Minuit, a Dutchman, buys the island of Manhattan for about 24 dollars—right away a fort is built and given a name: New Amsterdam.

1630 Staten Island is sold

1633 the first teacher comes over

1634 a priest serves Mass in the first church

1636 a doctor arrives

1640 by now an alert system of flags has been developed to warn inhabitants of unknown intruders

1644 the north is sealed off with a wall—the guards trample a path alongside it and later it becomes Wall Street

1650 the settlement's population reaches 1,500

1653 they build the first poor house

1656 the first fire hits the city

1658 night watchmen walk the streets—the first city police

1664 the British grab New Amsterdam from the Dutch and give it a new name: New York.

1665 the first court is established

1666 the first bank opens up on the corner of Wall Street

1670 sees the publication of *A Brief Description of New York*

1673 New York is temporarily renamed New Orange

1682 the first cemetery is consecrated

1694 the city laws are published

1697 at dusk every seventh house lights a lamp—the city has public lighting

1698 the Church of the Holy Trinity starts a library for parishioners

1699 the first theatrical performance takes place

1704 to much fanfare New York builds a city hall

1709 a slave market opens on Wall Street

1710 three thousand German immigrants sail in

1725 the first newspaper, *The New York Gazette*, comes out

1728 the first café welcomes customers on the corner of Wall Street

1750 the population of New York breaks 10,000—according to the first official census

1755 the city opens quarantine stations for new settlers

1760 blacks have their first school

1769 milestones are placed along the roads from City Hall

1776 the first hospital is built—and it immediately comes in handy: a battle takes place on Long Island—General Washington's soldiers pull back—the British take the city—fires destroy dozens of buildings

1784 now it's okay—the Brits had to clear out—the city gets its own crest

1789 George Washington takes office as the first president of the United States—the American Museum is established—a dozen businessmen decide to start a stock exchange just a few steps away from where the president was sworn in, where a big sycamore stands

1796 John Fitch tests his steamboat out in the river

1798 a yellow-fever epidemic breaks out

1811 the city has already gotten over it—a committee is now meeting to design new town squares and plan out the streets

1812 war with Britain breaks out, luckily it's short

1817 City Council passes a law to liberate slaves

1819 the first velocipede rides through the streets

1830 another attraction: the construction of the first railway

1831 New York founds its own university

1834 the bell of the first horse tram rings out, the first steam engine huffs and puffs on New York's outskirts

1835 alas, alas: seven hundred buildings up in flames

1837 Professor Morse thinks up the telegraph and Morse code

1838 north of the city prisoners dig cells into the cliffs of Sing Sing and the first baseball club is founded

1846 housewives rejoice: Mr. Elias Howe invents the sewing machine

1850 New York has 696,000 residents

1851 New Yorkers try out a new machine: the elevator

1852 policemen get uniforms: blue coats, gray pants, brass buttons

1853 drumroll, please . . . the Crystal Palace holds the first World Expo

1858 a cable is laid across the ocean from New York to Europe

1860 the Pony Express links New York to San Francisco and the Japanese send their first embassy to New York, their first diplomatic office

1865 the first telegraph wires are strung across the United States

1868 the first women's club is established

1870 work on the Brooklyn Bridge begins

1872 40,000 bricklayers strike

1878 first telephone switchboard

1880 the longest street in the world, Broadway, lights up with electricity

1885 city officials pass laws to limit the height of buildings, the first bus drives down Fifth Avenue, and the Statue of Liberty is dedicated at the entrance of the bay

1887 the first trams invade the city

1888 a blizzard rages for three days and nights, severing power lines and blinding the city

1892 the waves of immigrants keep on rising and Ellis Island becomes a receiving station

1893 four hundred of the richest New Yorkers throw an exclusive "Ball of the Century"

1899 an automobile parade processes along the main street—and here they are

1900 the first car races along the banks of Long Island and now New York already has 3,400,000 inhabitants

1901 the tallest building in the world, the twenty-seven-story Park Row Building, looms over the city

1904 subway service begins

1910 the population surpasses 4,500,000 and airplanes soar over New York

1915 the inventor Bell makes the first cross-country call from New York to San Francisco

1919 preparations begin for the first flights across the Atlantic

1920 among millionaires several billionaires start to stand out

1922 the first wireless dispatch is sent to Paris

1924 Radio New York begins to broadcast

1925 the entire city breathlessly watches a total eclipse of the sun as local prophets predict the end of the world

1929 Black Friday

1930 New York reaches a population of 6,900,000

1940 there are already 7,500,000 residents

1950 7,800,000

1960 begins to slip, barely 7,800,000

1970 holds steady 7,900,000

1980 down to 7,000,000

1990 up to 7,300,000

2000 up again to 8,000,000

it must be ready to burst!

or maybe not?

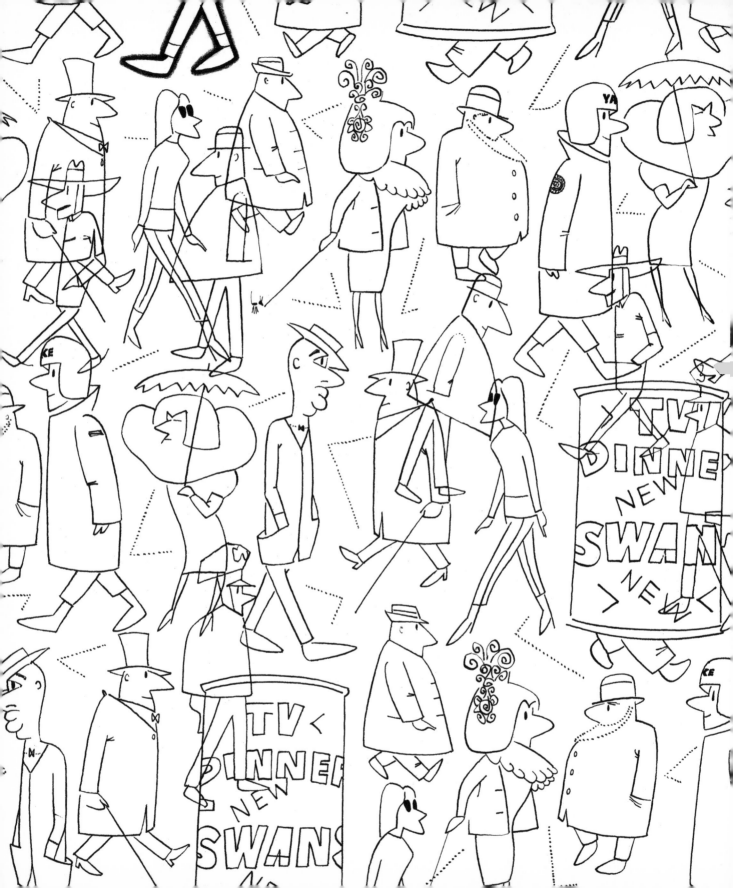

Some say that New York is not America. But most others strongly disagree.
New York, they say, is the real America, because living right here are Italians, Australians,
South Africans, Russians, Germans, Lebanese, Irish, Jamaicans, Puerto Ricans, Poles,
Haitians, Austrians, Koreans, English, Brazilians, Hungarians, Romanians, Canadians,
Scots, Israelis, Czechs, Slovaks, Swedes, Greeks, Egyptians, Norwegians, Japanese, Saudi
Arabians, French, Turks, Chinese, Spaniards, and so on and so on . . .

The notion that New York is like an anthill filled with ants rushing here and there or a beehive buzzing with constant activity—that someone coming here will be swallowed up and lost—just isn't true.

Just try to get lost here. You can't.

New York is carefully planned, filled with lined-up rows and right angles—just like a numbered chessboard, avenues extend vertically, streets cross horizontally. It's a game that never stops. You just need to know the pieces.

STREET STREET AVENUE STREET STREET AVENUE ST
STREET STREET AVENUE STREET STREET AVENUE ST
STREET STREET AVENUE STREET STREET AVENUE ST
STREET STREET AVENUE STREET STREET AVENUE ST
STREET STREET AVENUE STREET STREET AVENUE ST
STREET STREET AVENUE STREET STREET AVENUE ST
STREET STREET AVENUE STREET STREET AVENUE ST
STREET STREET AVENUE STREET STREET AVENUE ST
STREET STREET AVENUE STREET STREET AVENUE ST
STREET STREET AVENUE STREET STREET AVENUE ST
STREET STREET AVENUE STREET STREET AVENUE ST
STREET STREET AVENUE STREET STREET AVENUE ST
STREET STREET AVENUE STREET STREET AVENUE ST
STREET STREET AVENUE STREET STREET AVENUE ST
STREET STREET AVENUE STREET STREET AVENUE ST
STREET STREET AVENUE STREET STREET AVENUE ST
STREET STREET AVENUE STREET STREET AVENUE ST

BROADWAY BROADWAY BROADWAY BROADWAY BROADWAY BROADWAY

Some say,
"The bigger
the city,
the smaller
the person."

What do you think?

In the beginning, you could find your way according to crags, rivers, or a magnificent tree—these days you don't have dirt beneath your feet: you walk on asphalt and cobblestones and concrete. Once you used to see something to your right and something to your left. Now lots of things are up or down, too. Since water surrounds the island, there's no room to move outward. So they were forced to build up to the sky. Lights blink at the tippy-tops of buildings for pilots, and for us. Stand on your tiptoes and you'll see!

10
Tallest Skyscrapers

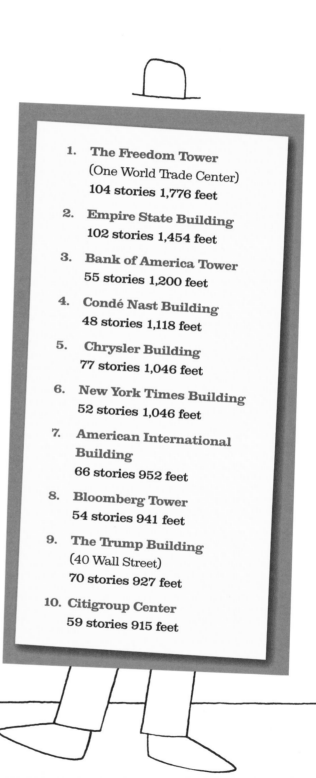

1. **The Freedom Tower**
(One World Trade Center)
104 stories 1,776 feet

2. **Empire State Building**
102 stories 1,454 feet

3. **Bank of America Tower**
55 stories 1,200 feet

4. **Condé Nast Building**
48 stories 1,118 feet

5. **Chrysler Building**
77 stories 1,046 feet

6. **New York Times Building**
52 stories 1,046 feet

7. **American International Building**
66 stories 952 feet

8. **Bloomberg Tower**
54 stories 941 feet

9. **The Trump Building**
(40 Wall Street)
70 stories 927 feet

10. **Citigroup Center**
59 stories 915 feet

New York moves fast.

It changes before your
eyes, and it'll never
be finished. When
the architect Richard
Morris Hunt built its
first skyscraper in 1874,
its nine stories towered
over the other buildings.
People would come to see
if it would fall. But it kept
standing, and they lost
interest, and turned their
attention to who would
build a higher one. And
now skyscrapers shoot up
into the sky everywhere,
light as a dream, hanging
in the heart of the night.

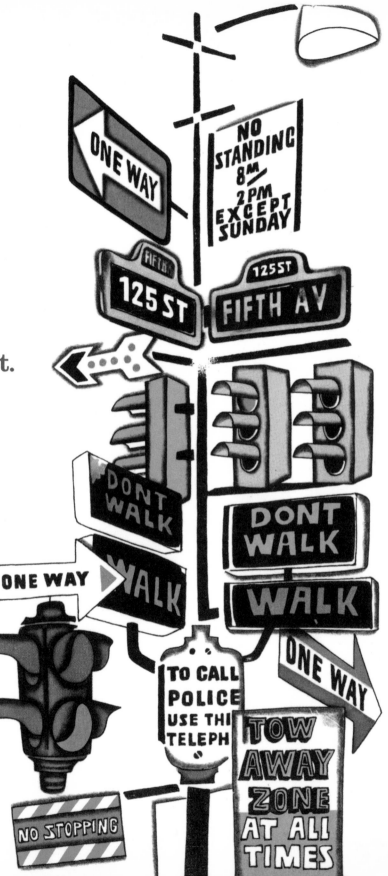

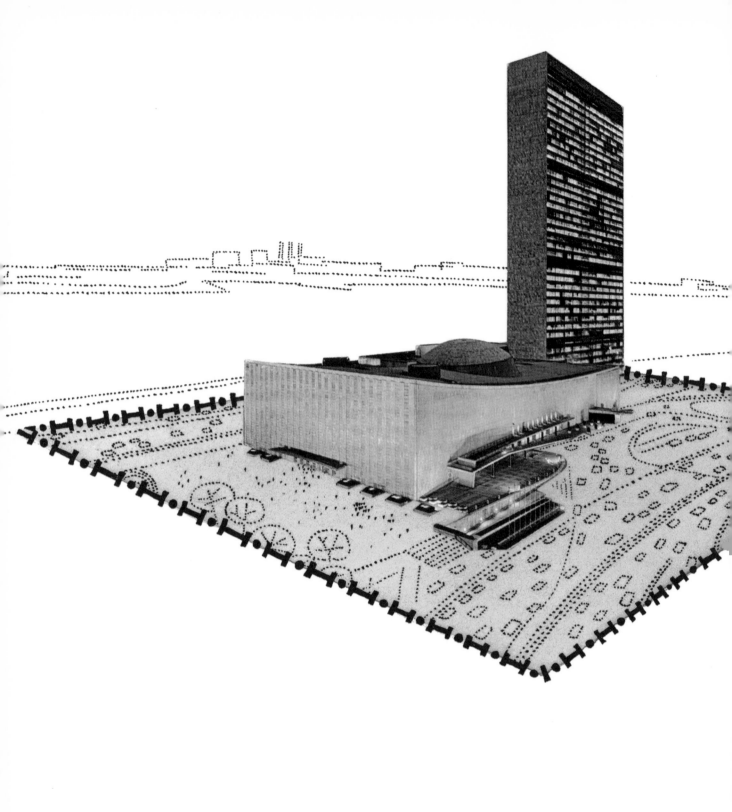

In a cherry orchard, behind a fanfare of flags, on international ground stands an amphitheater and a 39-story green glass building—the headquarters of the **UNITED NATIONS**, a campus that makes New York the capital of the world.

Ministers, premiers, presidents, kings, and even popes come here. Hosting nearly 1,800 conferences a year, the U.N. has speeches flying around in five languages at once, while, under an arch, a pendulum traces the rotation of the Earth.

Downtown, on Wall Street, you can follow narrow streets to the Federal Reserve.

There, seven floors beneath the street, a system of armored gates leads you to chambers filled with riches. During the day hundreds of thousands of employees work here, but it's a ghost town at night, a deserted iron-and-concrete ring.

Right around the corner is the Stock Exchange.

The stock market is like a track where, instead of horses, companies race. Want to try your luck? Just pay a quarter of a million dollars for membership and spend the rest on shares.

Then, watch an endless tickertape of coded letters and numbers to find out how your luck stands.

The hustle and bustle on the trading floor resembles a crowded railway station. Yet, above it all hovers not the steam of a locomotive, but a haze of memories: here old J.P. Morgan, with only a telephone at his ear, managed to earn a million dollars every day; here a grocer named James J. Hill became king of railroads; some millionaires, on the other hand, arrived here in a golden coach but left without much of anything.

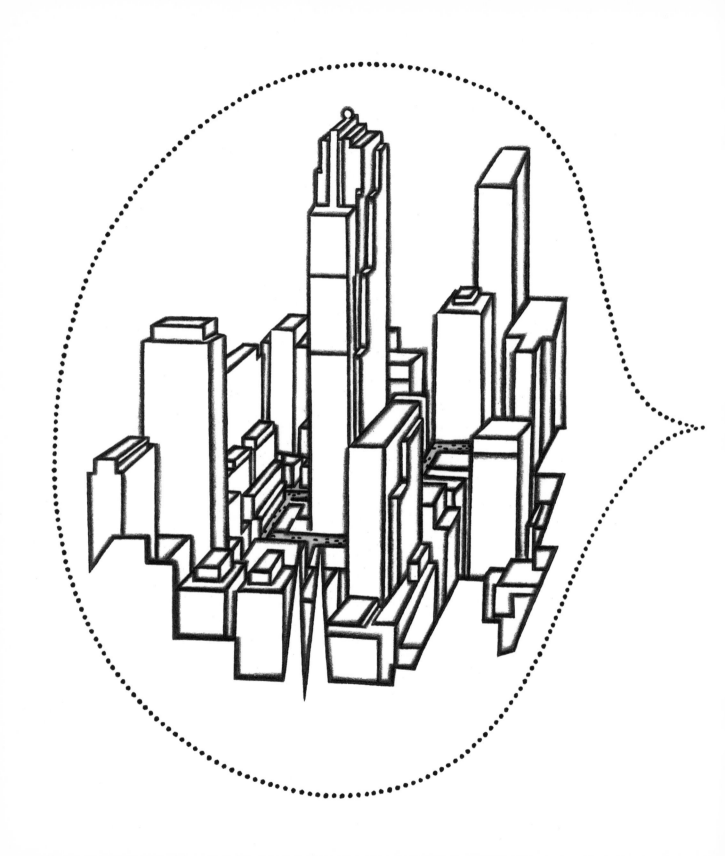

You could spend your whole life at Rockefeller Center—

a city within a city, with its
40 restaurants, post office,
publishers, banks, TV shows,
the biggest indoor theater
in the world, a skating rink,
a park with fountains and
a Christmas tree, and a
quarter of a thousand flowers
blooming on the roof.

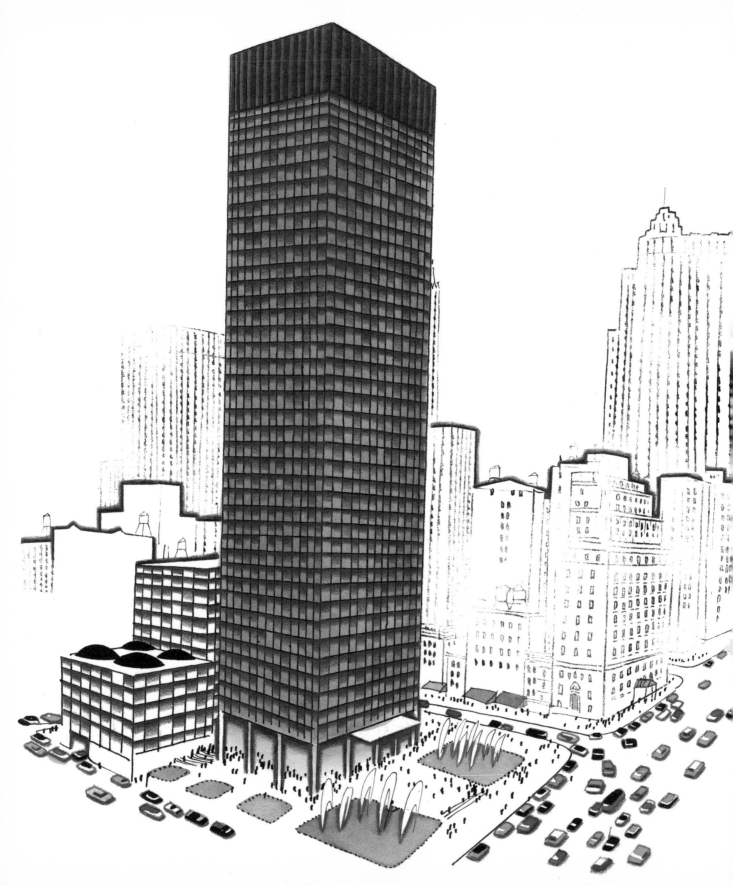

Can New York
be overwhelming?
It depends
on the person.

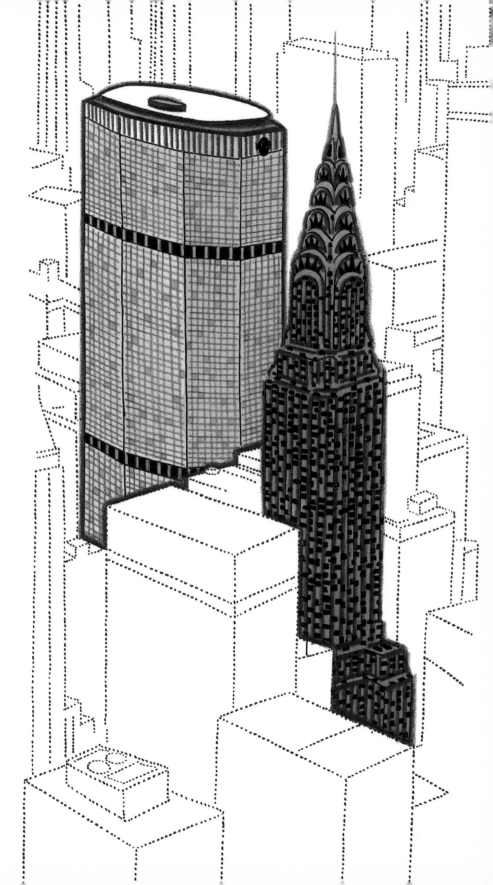

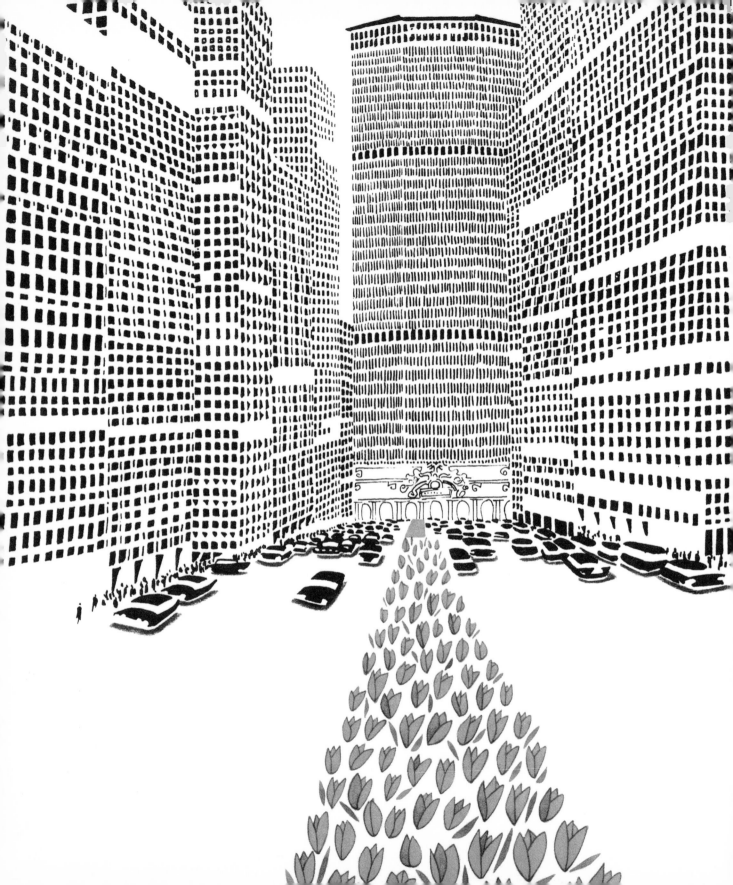

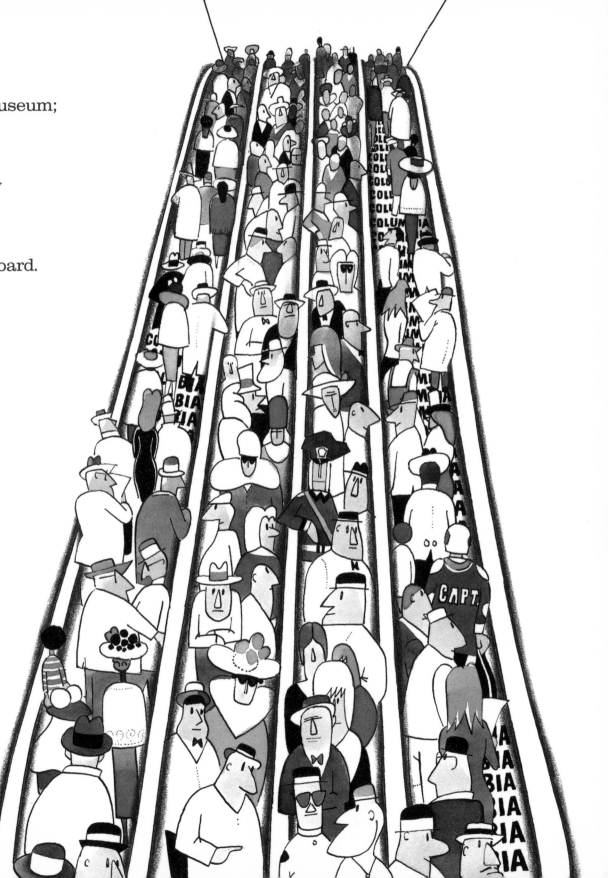

New York
is not a museum;
New York
is a
constantly
moving
current.
A switchboard.

It's amazing how it all works!

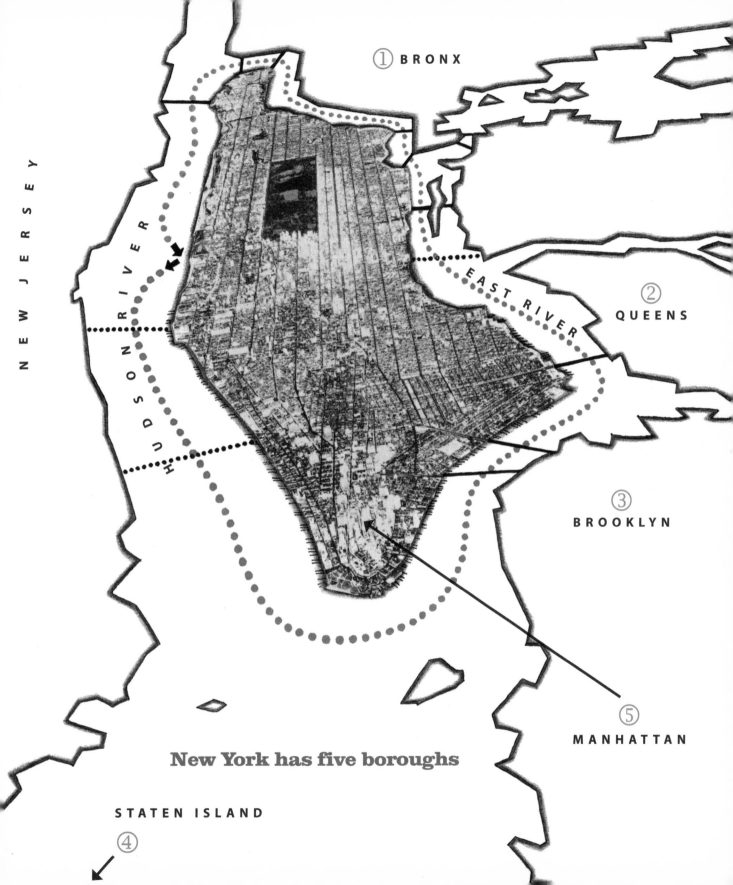

① BRONX

② QUEENS

③ BROOKLYN

④ STATEN ISLAND

⑤ MANHATTAN

NEW JERSEY

HUDSON RIVER

EAST RIVER

New York has five boroughs

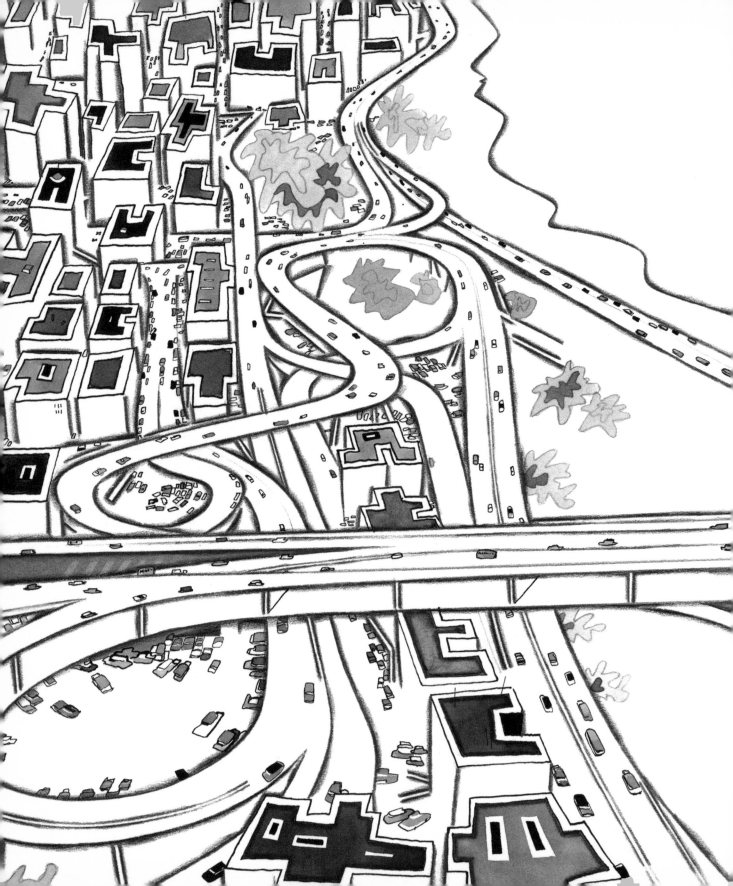

It's connected by
highways,
a concrete circulatory
system flowing
with **wheels.**
What was
meant to be an
intersection
ended up a fugue
in a ballet of
roadways.

There are three islands in New York. Along the shores, you can smell the scent of salt and iodine and sweat as fish and bananas are loaded and unloaded. Eyes glint and gleam in the sunlight, as they watch ships sail off toward the horizon, and toward adventure.

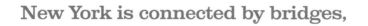
New York is connected by bridges,

slender as bows, like harps of gods or
pterodactyls fossilized in midflight.

Verrazano-Narrows Bridge: Until 1981 its main span was the longest in the world, hung from seventy-story pillars.

Brooklyn Bridge: A treasure handed down from father to son, a triumph about which songs have been written.

George Washington Bridge: A necklace made of lightbulbs, whose two levels host more than 280,000 cars each day.

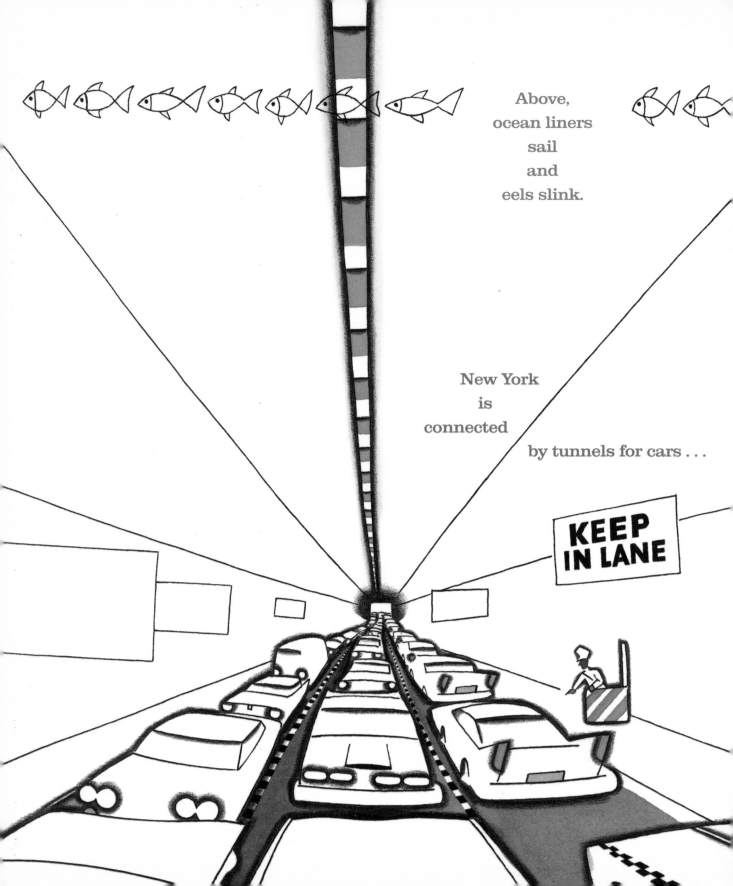

Above,
ocean liners
sail
and
eels slink.

New York
is
connected

by tunnels for cars . . .

KEEP
IN LANE

57TH ST

CONEY ISLAND

M · 4

... and tunnels for underground trains. New Yorkers try to keep a map of the subway in their heads, but most commuters only know their own train routes.

I LIKE THE N.Y. SUBWAY

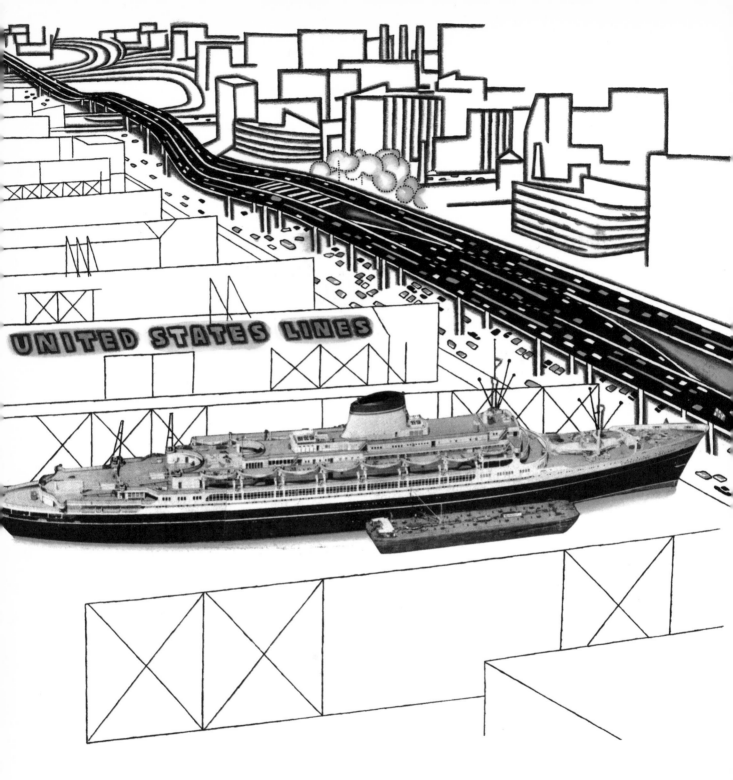

New York is connected to the world by ports. The docks line up and look like a comb stuck to the side of the shore, or the teeth of New York biting at the waves.

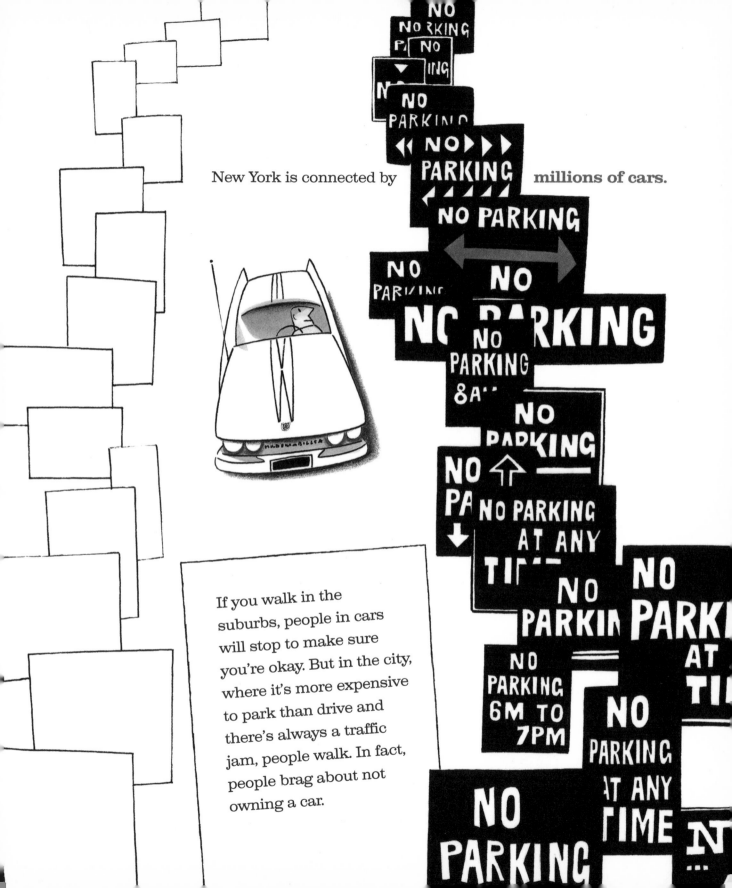

New York is connected by **millions of cars.**

NO PARKING
NO PARKING
P; NO
▼ ING
NO PARKING
◀◀ NO ▶ ▶ ▶
PARKING
◢◢◢◢
NO PARKING
NO
NO
PARKING
NO PARKING
NO
PARKING
8A
NO
PARKING
NO ⬆
PA
↓ NO PARKING
AT ANY
TIME
NO
PARKING
NO
PARKIN
PARK
AT
TI
NO
PARKING
6M TO
7PM
NO
PARKING
AT ANY
TIME
NO PARKING
AT ANY
TIME
N
...

If you walk in the suburbs, people in cars will stop to make sure you're okay. But in the city, where it's more expensive to park than drive and there's always a traffic jam, people walk. In fact, people brag about not owning a car.

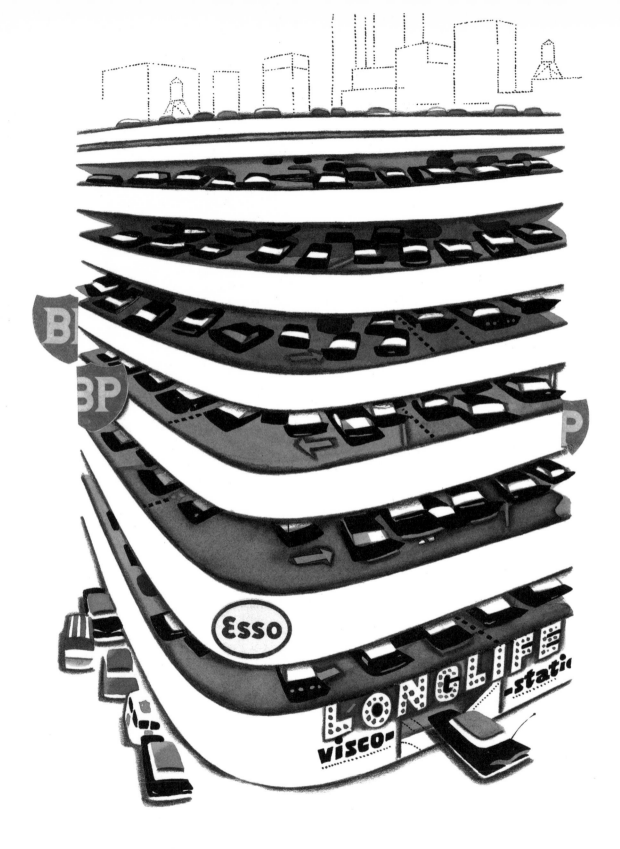

And so cars climb up and up to find parking, just like people going to their offices, and radios drive herds of taxis toward the spacious streets and green-light forests of the outer boroughs and suburbs.

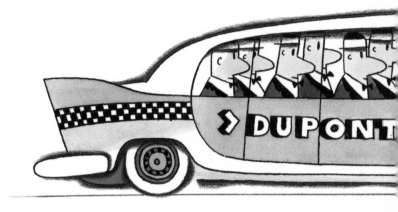

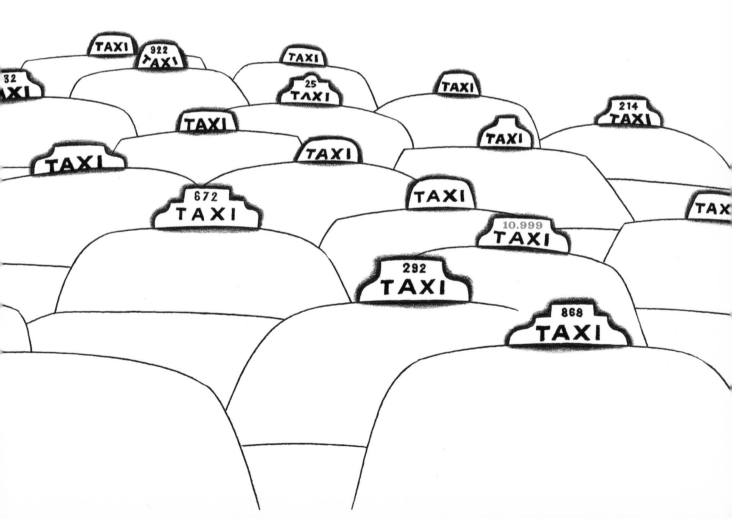

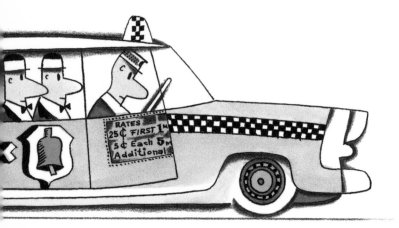

The best option in the city is mass transit. Trains and buses are the fastest way to get around.

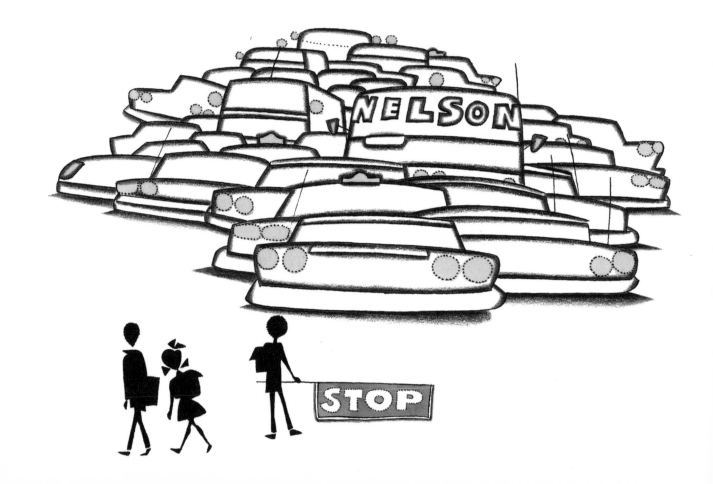

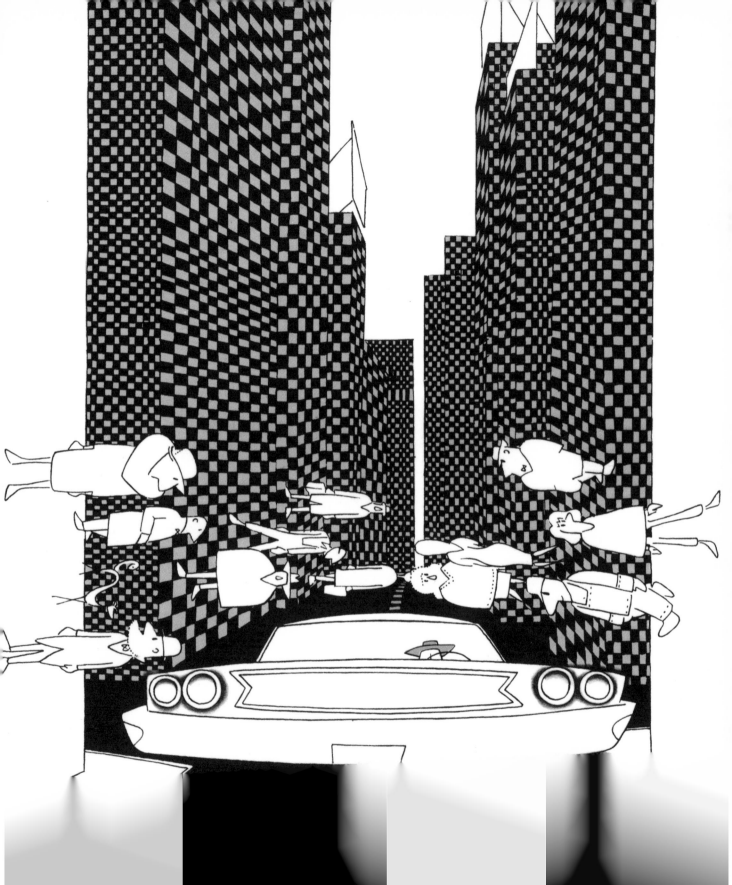

And the city air?

New Yorkers never think
there's enough and it's either
too hot or too cold. Fortunately
the farsighted forefathers
set up Central Park! Not that
they were worried about
global warming—back then
they just wanted a lawn, a
picnic place, something for
Sundays. They took a 700-acre
rectangle of land, displacing
Irish pig farmers and German
gardeners and an African
American settlement. Now this
oasis functions as the city's
green lungs.

Shaded by skyscraper hedges,
children play as owls shriek
from the oak trees.

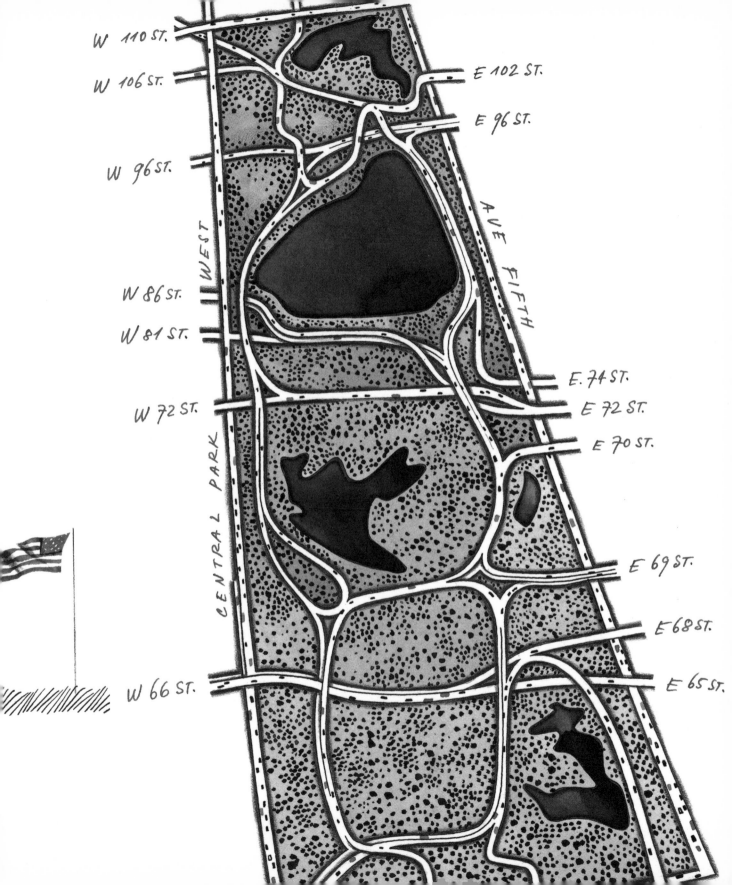

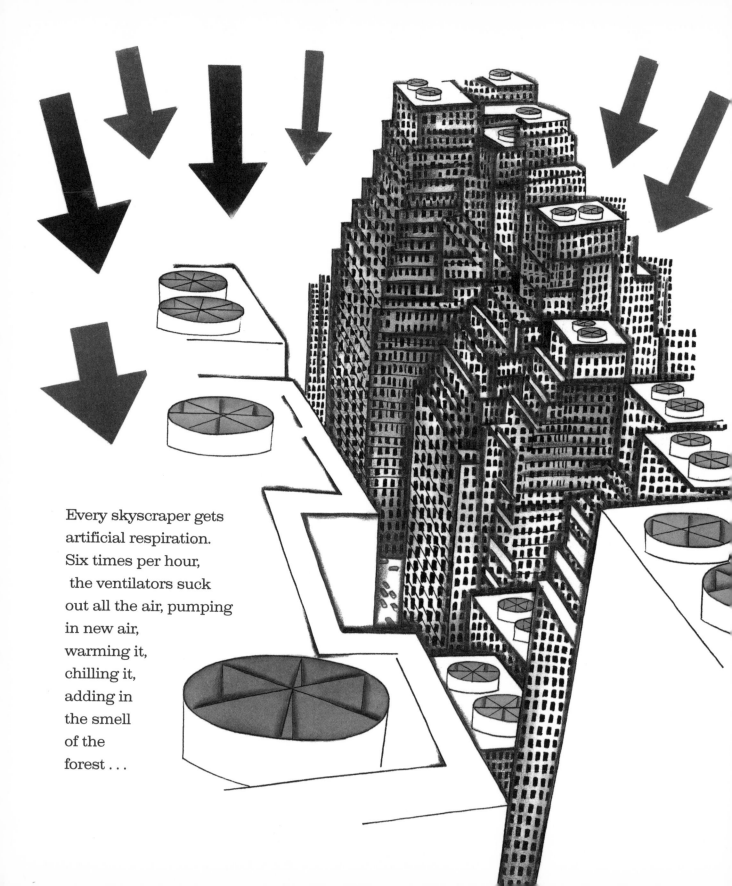

Every skyscraper gets
artificial respiration.
Six times per hour,
the ventilators suck
out all the air, pumping
in new air,
warming it,
chilling it,
adding in
the smell
of the
forest . . .

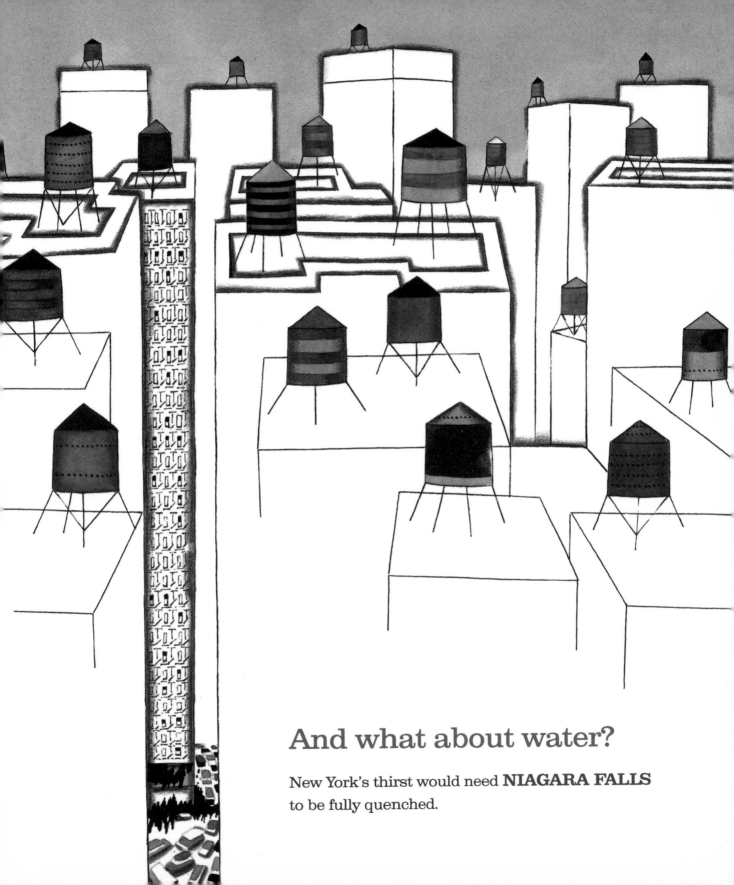

And what about water?

New York's thirst would need **NIAGARA FALLS**
to be fully quenched.

Water:

gallons of gold!

New York's heroes are the firefighters. **Red engines** run through the streets with their chrome **gauges gleaming** and **horns blaring**. Along with police and ambulance sirens, they make up the ever-present **background music** of the city.

And what about light?

One November at five-thirty at night, a power plant broke down on the border between America and Canada. New York sunk into darkness; houses, billboards, streetlights, and traffic lights went out. Fifty thousand elevators were stuck, subways and escalators stopped, televisions went blank, and radios were silent, printing presses froze, time stood still. Intersections were jammed with cars. The city was paralyzed. Twenty-five thousand policemen went out with megaphones:
No one panic!
For the first time everyone understood—
New York runs on
ELECTRICITY.

If something doesn't seem right, dial

emergency	911
or the **police**	911
or a **daily prayer**	1-800-4-PRAYER

. . . or you can write to the mayor:

c/o City Hall, New York, NY 10007

MANHATTAN MAIL ONLY

US. MAIL

TEMP°: 59°

★
UNITED

TIME '4:'2

UNITED
AIR LINES

But when the electricity flows,
New York glimmers like a screen
of vacuum tubes. The wires
that connect the city lie below.

Another city lies underneath this one . . .

A web, a net, a machine.

B29

G
2

7

The city is awakened right before sunrise by the hundreds
of women and men on their way to work. Hospital employees
and waiters come out as fresh meat and produce are loaded,
unloaded, prepared, and consumed for breakfast by the city's
workers. It is the most important meal of the day.

5

2

8:

Uptown, you can sit, sipping tea, and have a fabulous conversation as store clerks see to your every wish. You will be presented with one-of-a-kinds in the latest style. You don't ask the price, you don't even pay (the cashier withdraws the sum from your account), and you don't take your purchase with you—a messenger delivers it.

A street filled with diamonds runs in **Midtown**, as does a street for shoes, a street for paintings, a street for electronics, a street for toys, and a street for brides.

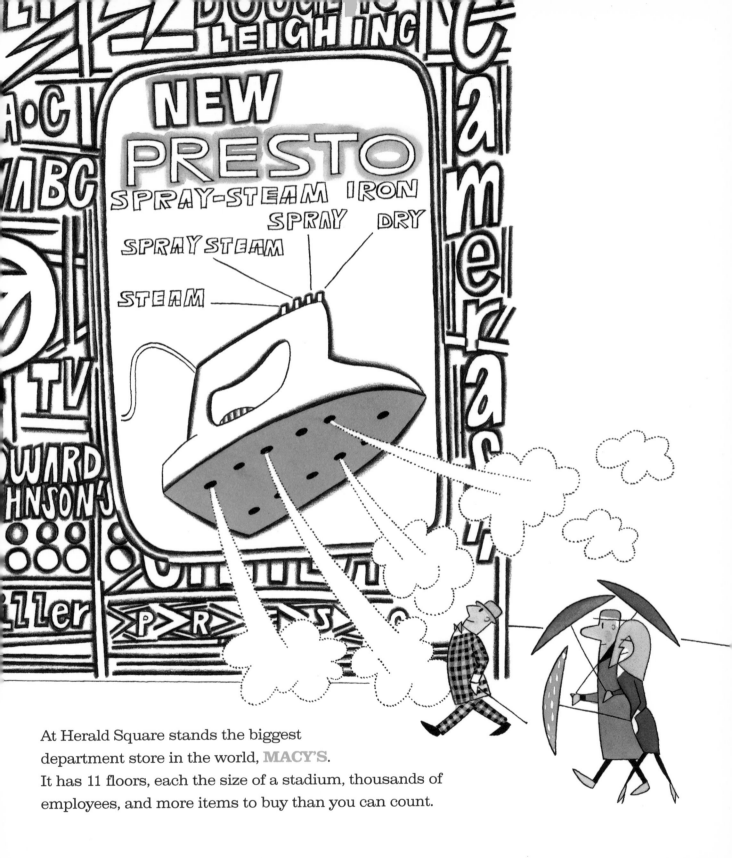

At Herald Square stands the biggest
department store in the world, **MACY'S**.
It has 11 floors, each the size of a stadium, thousands of
employees, and more items to buy than you can count.

72

In New York it's possible to buy the impossible:

Shark meat—armor—the signatures of famous
men—snowsuits for dogs—Communion wafers—
model ships in bottles—Picassos—shot-up flags
from battleships—Inuit toys—bird's nest soup—
ancient Greek wedding rings—acting classes—
Renaissance maps—belts for robes—gag gifts
and pranks like spiders to drop down a shirt—you
can order a conversation with Santa Claus, a
babysitter, handwriting analysis, a psychiatrist for
your cat—they have experts on Gothic and Louis
XIV furniture—booksellers specializing in flying
saucers and yoga—

Ladies and Gentlemen, step right in!

press a button press a button press a button press
chocolate—tickets—nuts

a button press a button press a button press a
stamp—ice cream—change

button press a button press a button press a but
pencils—music—milk and juice

ton press a button press a button press a bu
cookies—photos—
horoscopes and soup

on press a button press a button press a button
pick yourself a bride or a groom

ISION OF SPERRY RAND ION

Machines are
sometimes **easier**
to deal with **than people.**

Some people own an entire floor by **Central Park,**
one with a pool on the roof, original art on the walls.

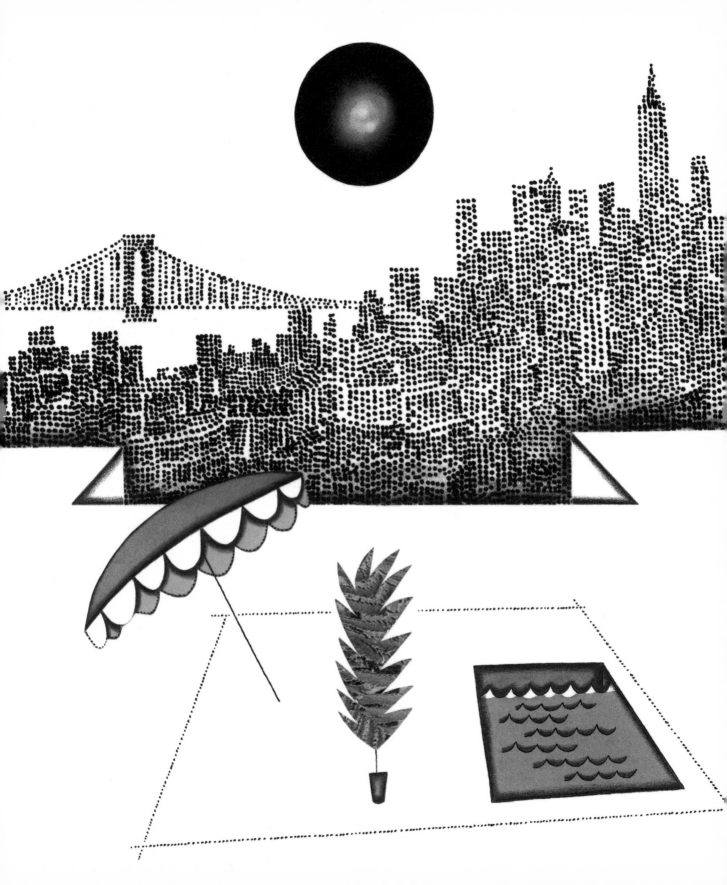

EMPIRE STATE

Others have a more **subtle elegance** as they travel

from their apartments to build elevators.

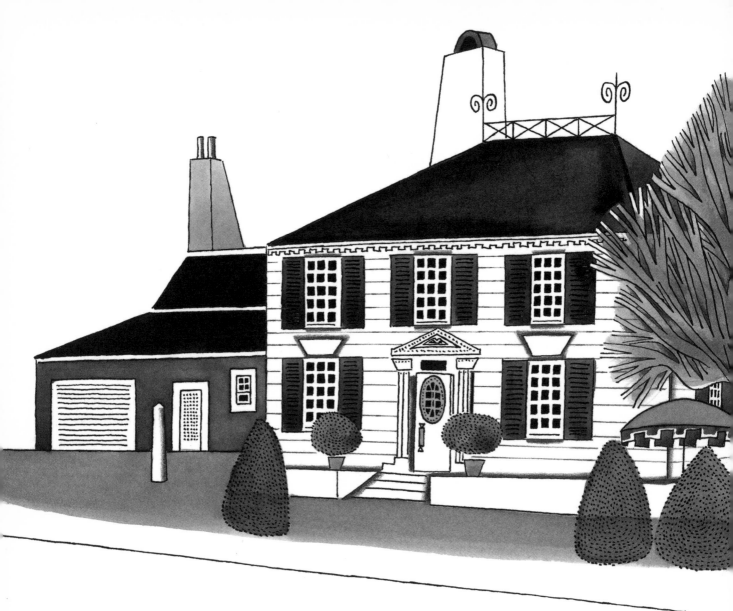

Still others own a nice house in **Queens.**

The
workday ends
when
rush hour
takes everyone
home.

=

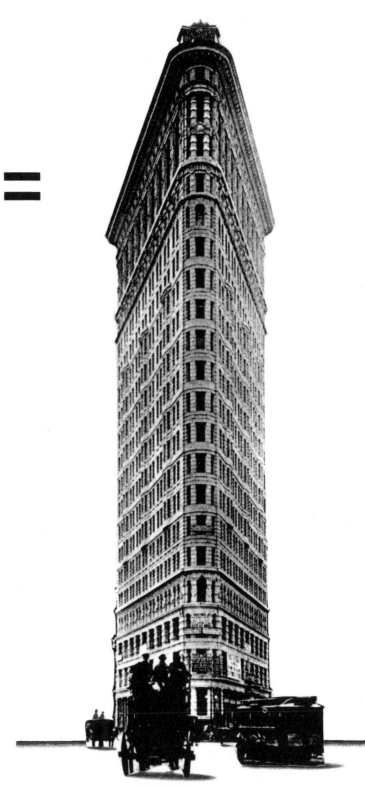

There are all sorts of buildings here.

The **Flatiron**
isn't all that
flat, really.

Everyone enjoys their weekends. In New York, leisure is an art.

Lose yourself in the newspaper.
Newspapers are artworks of
abbreviation. They squeeze
descriptions into headlines; photos
replace words. Have a look.

The television is on. In New York television broadcasts all the time:

News **ads** spaghetti **ads** westerns
ads butter **ads** fly **ads** 100 **ads**
meter **ads** late **ads** night **ads** show
ads news **ads** foot **ads** ball **ads**
inter **ads** view **ads** spy **ads** movie
ads Gemini **ads** count **ads** down
ads it **ads** is **ads** fan **ads** tastic
ads to **ads** see **ads** it **ads** all.

Get a hobby

But there's more to do than just watch television!

Get a collection of butterflies or old postcards.
Get a workshop with enough tools for a superintendent.
Get a lawn with tea plants, a silver fir, and a tame squirrel.
Get a plaster angel, a pond, and a couple of newts.
Get all those unnecessary necessities.

AROUND
MANHATTAN

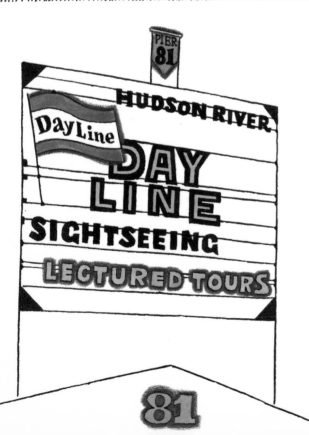

If the woods aren't
your thing, you can
take a cruise . . .

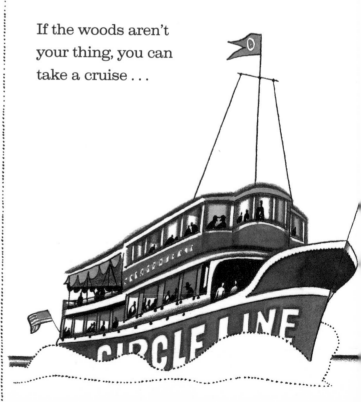

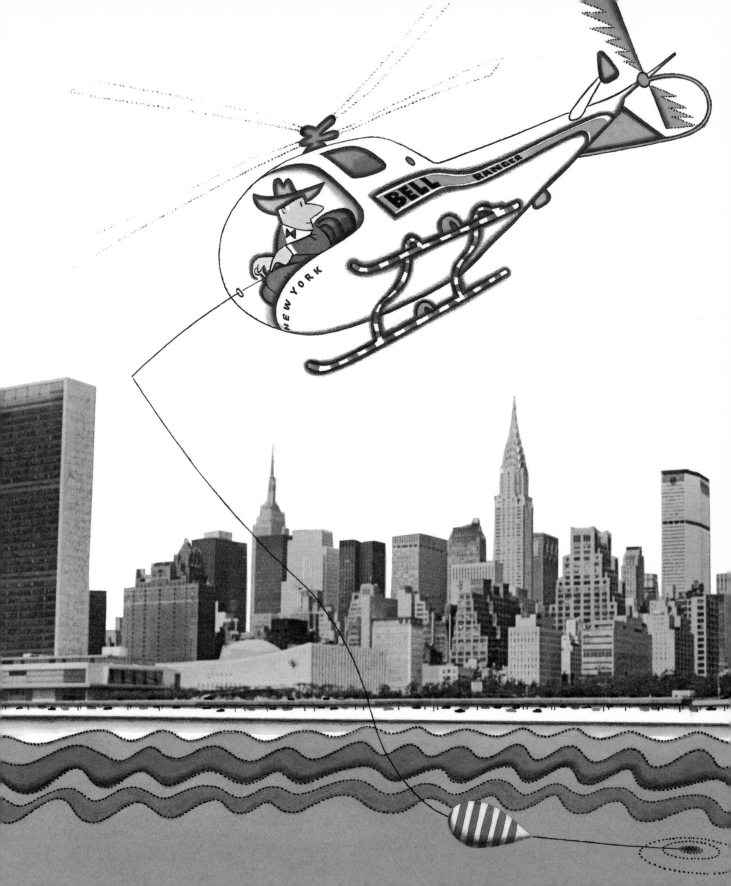

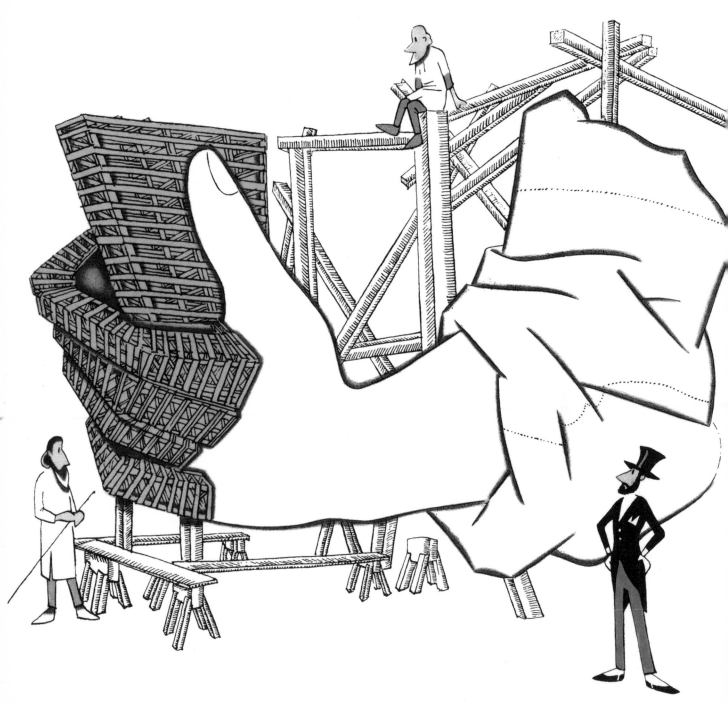

... until it anchors off an island called Smaller or Oyster or Love or Liberty, where an elegant green lady who measures ten feet from ear to ear lives. One of her fingers measures eight feet long, and she stands on a star-shaped fort.

Visitors climb 354 steps of a spiral stair and, when they reach the head, can check another goal off their list of adventures ...

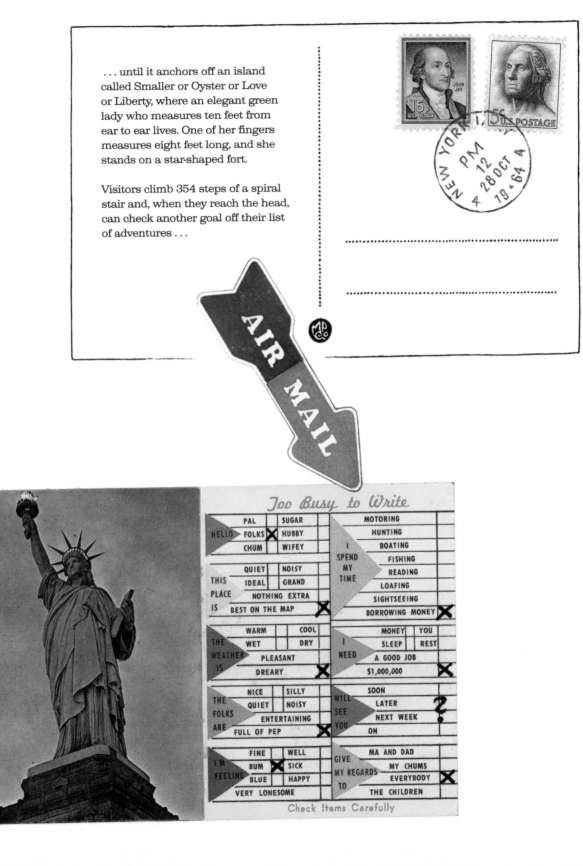

Stroll through the museums.

And you can go all year long—they have whole little worlds stored in them. But don't rush through them or you'll miss the beauty. Take your time in looking at sculptures chiseled from volcanic rock, paintings that smoke, totems that are phantoms, the mask of a possessed god. Eventually, you'll be able to wander around a museum like you are in an ancient forest seeing your life, and all of history, as it's laid out along the rings in a giant sequoia slice. You were born here, Verrazzano came to New York here, Rome fell here, until you come upon a point when CE turns into BCE and everything goes backwards . . .

Museums can be found throughout New York. Mr. Rockefeller transplanted five medieval monasteries from Europe, each taken apart stone by stone and then reassembled up in northern Manhattan, and called his museum the Cloisters. Fifteen thousand foundations support science and art with billions of dollars per year.

Lincoln Center houses
theaters ❶, a museum ❷, Juilliard ❸, a library ❹,
an opera house ❺, and concert halls ❻.

Galleries
are in ample
supply, too.

Some are devoted to entire movements; halls are dedicated to Rembrandts, temple gates, castle ceilings, tombstones, armor, antiques, and contemporary furniture. You'll see names that epitomize modern art written on works so famous you thought they were just legends.

Everybody takes something away from their time in New York:
some with them, others within them.

Stroll through a bohemian paradise that is the independent republic of Greenwich Village.

It's here that you can lounge in cellars among students and playwrights and actors as music flows from speakers like molasses, lubricating creativity and electrifying the atmosphere. Poets recite their latest inside while outside in Washington Square, guitarists shuffle around a fountain, trading songs from the Wild West and Deep South. Freshly painted canvases hang from the trees— cool ones and kitschy ones and incredible ones that hint at promising rebels who think they know what they're against, but aren't quite sure what they're for . . .

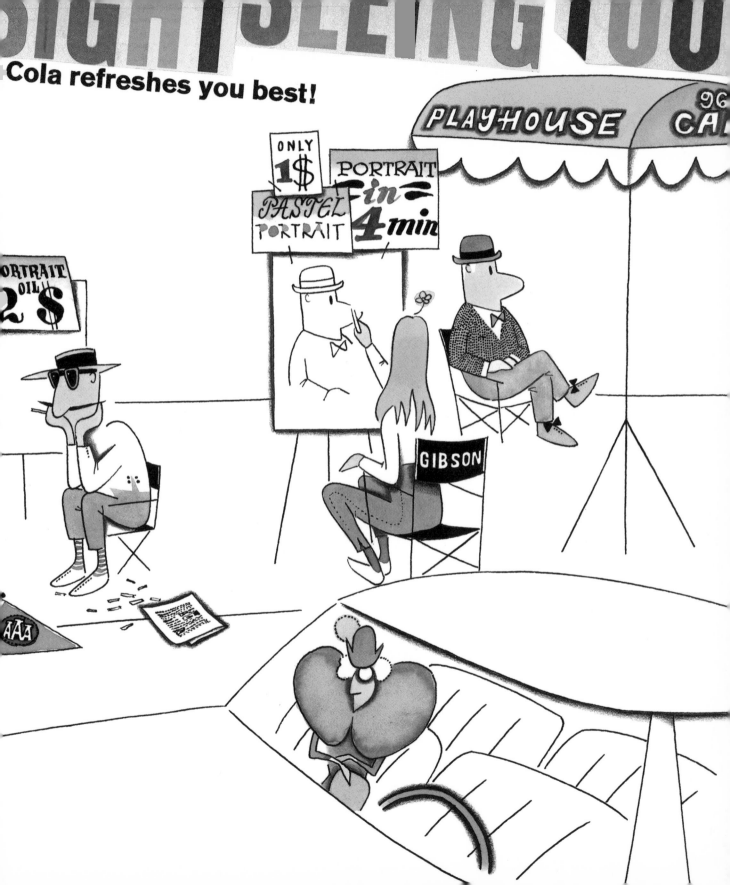

Go to Broadway, where thousands of lights illuminate and cascade like fluorescent waterfalls and shimmy across the facades.

You'll come upon a sparkling intersection crowded with people pushing through a neon downpour with rubber necks and spirals in their eyes—they try to see everything in this electric geyser called Times Square. It is here where stars are born.

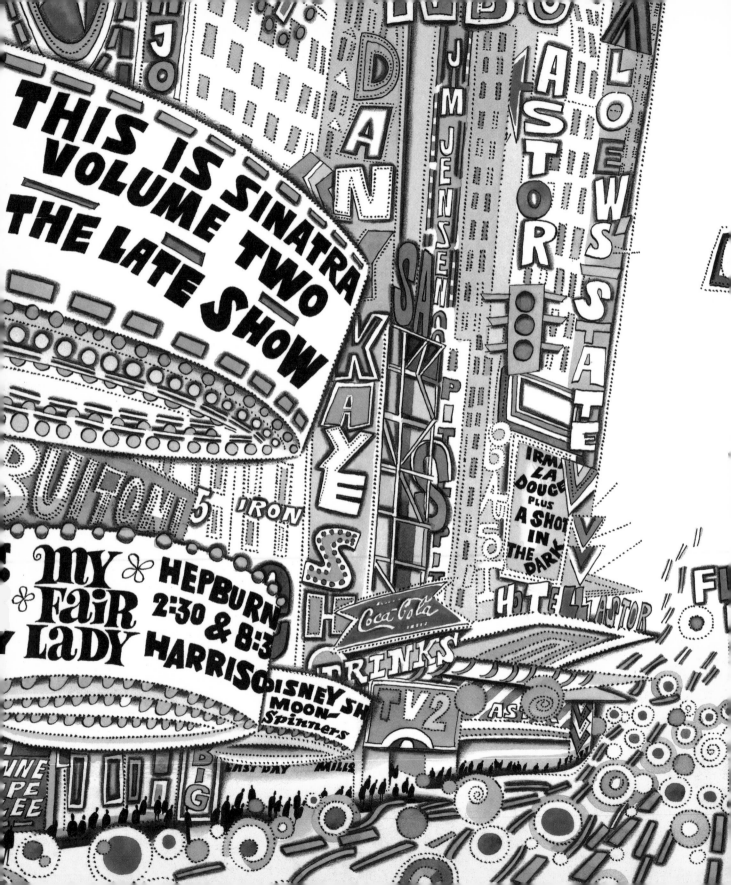

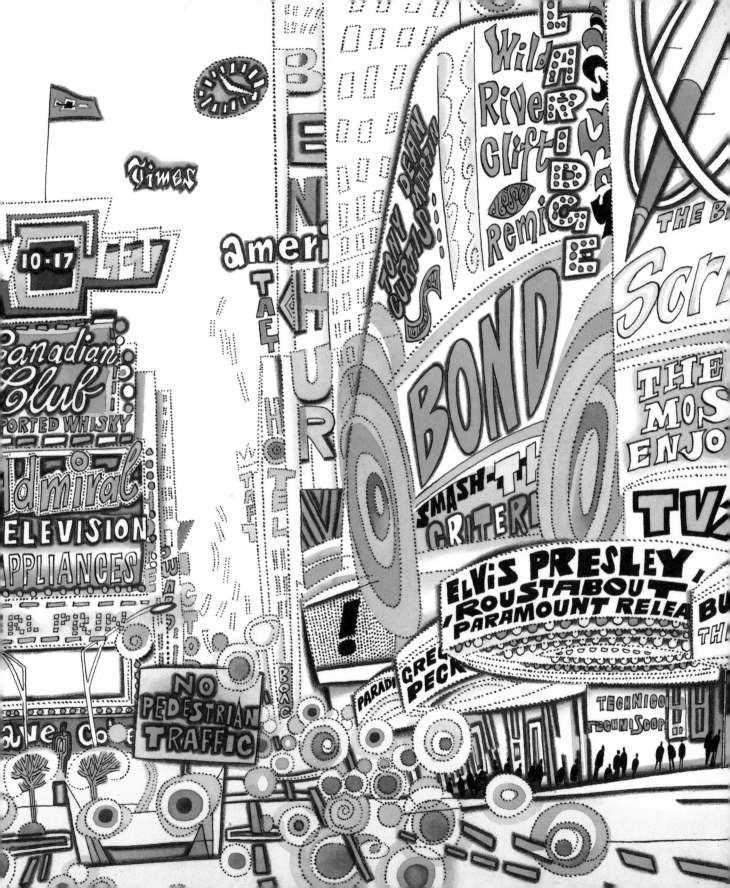

And jazz is played ROUND and ROUND:

The moon is black, the rhythm exposed

Village Vanguard

The heart beats against the ribcage

Small Paradise

The apostle preaches through a trombone

Birdland

A proclamation of integrity in fits

Basin Street

Jazz—the bitter name of our century.

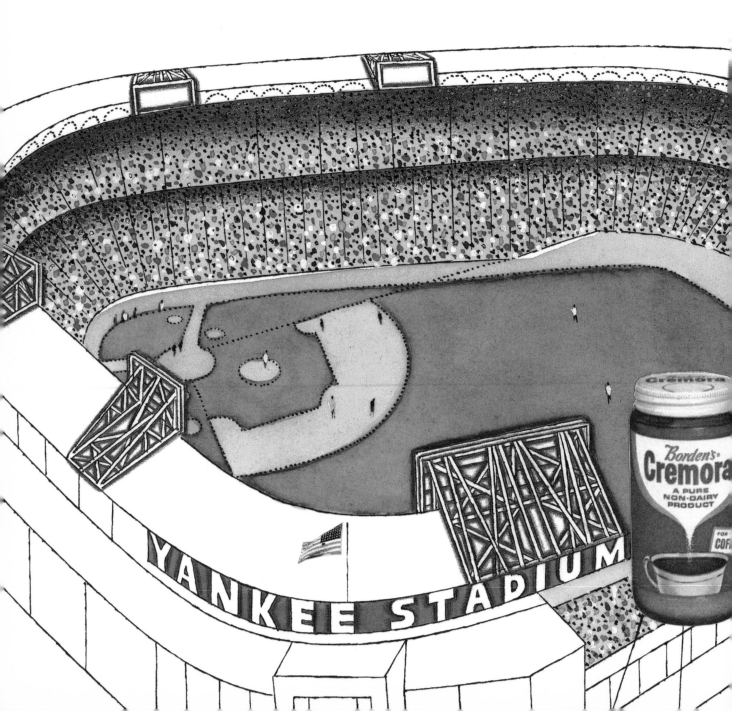

American football is handball, or tackleball actually; better yet it's more of a massive huddle, and then the whistle blows and there's another time-out, there's always a time-out— American football is a time-out from the time-outs. Seventy thousand fans constantly jump out of their seats. (**Ditto for baseball.**)

Fill a stadium.

Heaven for kids—**FREEDOMLAND**
Once upon a time (1960–1964) up
north lay an 85-acre map of the
USA. An old-fashioned train chugged
through it hauling the young through
history: it kicked off with a Civil War
battle—actors in costume attacked
from each side—and the Great
Chicago Fire broke out every hour—
children worked the pumps. From
there they headed out by stagecoach
along Gold Rush routes and through
Native American territory—and then
up on the steamboat and down the
Mississippi—or by canoe across
the lakes to be among the trappers
in the virgin wilderness—or by foot
to the ice cream shop!

CONEY ISLAND is the region of
rides: carousels, games—rainbow
bright and bubbling until the first
frost, when it's quiet and prowled only
by tigerlike cats with philosophical
eyes. Only the aquarium beats with a
quiet pulse—fish like targets, flutes,
flames, forks, and feathers flitter
through the murk, eyeing you—
beautiful beyond belief—Paleozoic
witnesses to all of history . . .
You get goose bumps: I'm never going
in the sea again! Until the sun comes
up . . . and New York swarms onto a
three-mile strip of canary sand.

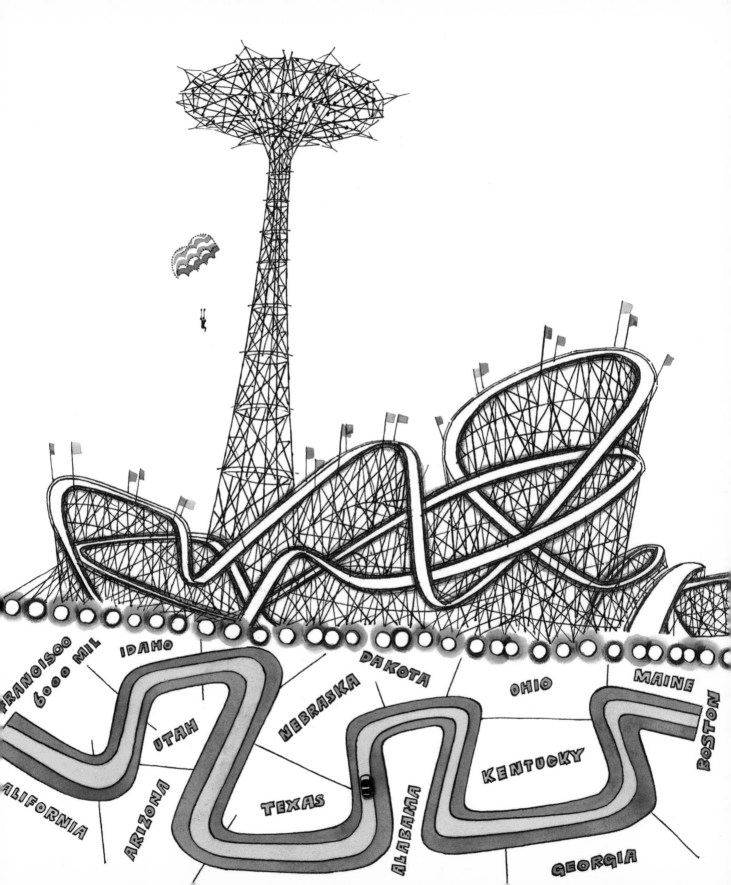

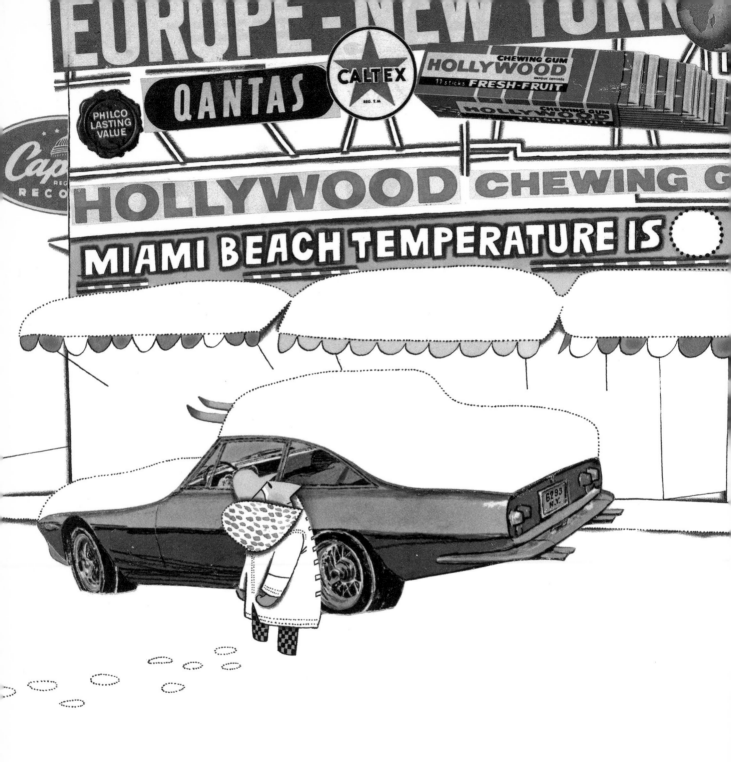

January	33° F
February	33° F
March	41° F
April	50° F
May	61° F
June	70° F
July	75° F
August	73° F
September	67° F
October	57° F
November	46° F
December	36° F

"Snowfall on your holiday? Miami Beach awaits!"

"Buy a bus pass! Crisscross all the states!"

Don't go anywhere—New York's got it all from January to December

January New Year fireworks explode over the Hudson River; kids can't get enough of winter sports

February New Year fireworks explode over Chinatown; Madison Square Garden prepares for the dog show; Thomas Edison's birthday falls on the 11th and Abraham Lincoln's on the 12th

March St. Patrick's Day is in the middle of the month—those of Irish ancestry celebrate the holiday; Greek Independence Day falls on the last week

April baseball and horseraces begin; Coney Island gears up to open; cherry blossom season approaches

May Cinco de Mayo is celebrated every 5th; Mother's Day is the second Sunday

June the ships are blessed in early June—look for a nearby harbor to find the date; the 14th is American Flag Day and the third Sunday is Father's Day; model makers are ready for the first summer day—the Central Park Conservatory Water hosts the frigate championships; St. John the Baptist Day—the 24th—is famous as a Puerto Rican holiday and Randall's Island shakes to the rhythm of salsa and cha-cha

July decked out veterans march down Fifth Avenue—it's the 4th, Independence Day; school kids set off on vacation; the city lies on the beach

August free concerts in parks and public spaces make summers festive; St. Stephen's Day—the 20th—belongs to Hungarian Catholics; an outdoor art exhibition in Washington Square begins in the last week and goes for the whole next month

September football season begins; Labor Day is celebrated on the first Monday of the month; a new moon may mark the Jewish New Year; Constitution Day falls on the 17th; the German parade—Steuben Day—is held at the end in honor of the general who fought by Washington's side

October the Polish version is called Pulaski Day, which falls on the first Sunday of the month; and yet another parade is organized for second Monday—for the anniversary of Christopher Columbus's discovery of America; the month culminates with the 24th—United Nations Day

November elections are on the first Tuesday; on the 11th all kinds of veterans in full regalia march out again—it's Veterans Day; St. Cecilia, the patron saint of musicians, gets her turn on the 22nd; and here comes the last Thursday of the month, Thanksgiving Day—children can't wait to see the parade along Central Park as floats go by with TV stars and scenes from fairy tales, above them flying giant cartoon characters

December Hanukkah candles glow for eight nights; department stores compete with one another in decorating for Christmas sales; crèches— up to 65 feet long—glow before churches; the planetarium shows the configuration of stars during Jesus's birth; the Salvation Army collects for the poor; parents line their houses with lights of every color; Gregorian chants echo

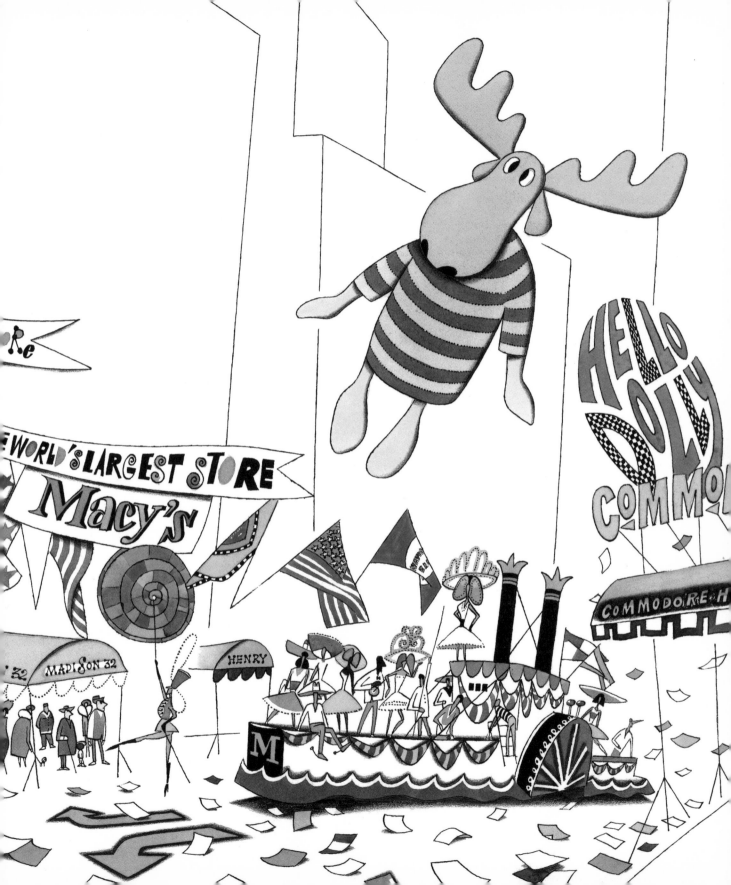

New York, they say,

is like **poetry**.

is a **melting pot**.

is a giant **crystal ball** in which everyone can see their own future.

Once you've seen New York, you don't have to see anything else.

New Yorkers, they say,

are not just New Yorkers.

They are the most American of all—as soon an immigrant steps ashore in New York, he shouts, "I am an American!"—and with that, he looks like an American.

The people who live here are both united and eclectic. They stand together in their differences. They are like sparrows, able to fly on the currents of change. They can play and make messes like children but can work like grownups in white shirts and black suits.

	AMERICAN	GERMANS	ENGLISH	FRENCH	ITALIANS	YOU?
Hardworking	68	19	32	37	39	...
Intelligent	72	34	38	37	34	...
Practical	53	45	38	81	59	...
Magnanimous	22	15	52	24	22	...
Altruistic	76	46	52	34	60	...
Barbaric	2	2	3	4	3	...
Primitive	2	1	4	2	2	...
Brave	66	6	19	26	18	...
Stoic	37	11	10	34	16	...
Authoritative	9	10	37	46	11	...
Progressive	70	58	58	75	32	...
Peaceful	82	23	39	26	29	...

What do you think?

P. S.

Ano, náš „New York" je bezmála půl století starý: skizza vznikla v roce 1964 a byla vytištěna jako vánoční dárek. — Jenomže: Vladimír Fuka, kterému choroba krutě zkrátila čas, se rozhodl strávit zbytek života v americkém exilu ... Na to estébáci odsoudili celý náklad do stoupy. Přežil jediný výtisk: stačil jsem odnést aspoň archy nátisků — z nich přece si zbyl maketu. Ležela pak léta zasuta na dně rukopisů. Až tohle léto přiletěl na prázdniny vnuk z Harvardu, vyhrabali jsme to zpola zapomenuté dílo — a on mě pak pomohl: „Proč to nevydáš?" Odvezl jsem tedy svazek do Albatrosu — zbyla třeba měli zájem ...

Tak se náš „New York" konečně dostává ke čtenářům: kéž vám — byť opožděně — udělá radost!

Zdeněk Kalina
17. října 2008

P.S.

Yes, our *New York* is almost half a century old. The book was written in 1964 and was printed as a Christmas present—except Vladimír Fuka, whose time was cut cruelly short by illness, decided to spend the rest of his life in exile in America . . . For that the secret police condemned the entire printing to the pulper. Only one copy survived: the proof sheets I had managed to grab and I glued them together to make a mock-up. For years it lay at the bottom of a pile of manuscripts—until this year when my grandson came to visit from Harvard. We dug up the half-forgotten work, and he prodded me: "Why don't you publish it?" So I brought the book to Albatros—just to see if they might be interested . . .

So our *New York* is finding some readers at last—and although it's late, I hope you like it!

Zdeněk Mahler
October 17, 2008

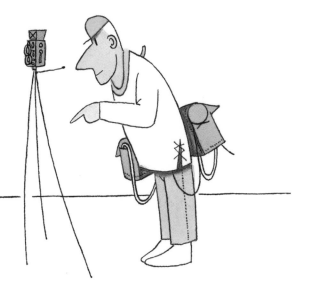

Published by arrangement with
Albatros Media a.s., Prague

This edition first published in the
United States of America in 2014 by
UNIVERSE PUBLICATIONS,
A Division of Rizzoli International
Publications, Inc.
300 Park Avenue South
New York, NY 10010
www.rizzoliusa.com

© Illustrations Vladimír Fuka -
heir, 2008
© Text Zdeněk Mahler c/o
DILIA, 2008
Pages 99 - 100 © Successió Miró /
Artists Rights Society (ARS), New
York / ADAGP, Paris 2013

Translated by
Mike and Tereza Baugh

English edition adapted by
Universe Publishing, 2013.

2014 2015 2016 2017 /
10 9 8 7 6 5 4 3 2 1

Distributed in the U.S. trade by
Random House, New York
Printed in the Czech Republic

ISBN: 978-0-7893-2727-7

Library of Congress Catalog Control
Number: 2013948772

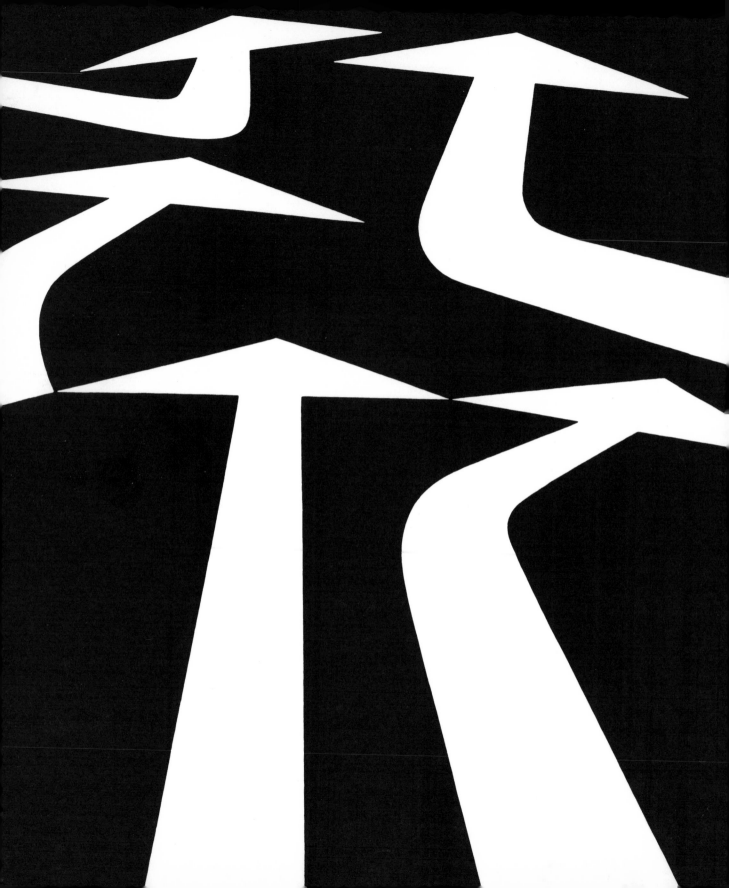